IMAGES
of America

BALTIMORE
COUNTY

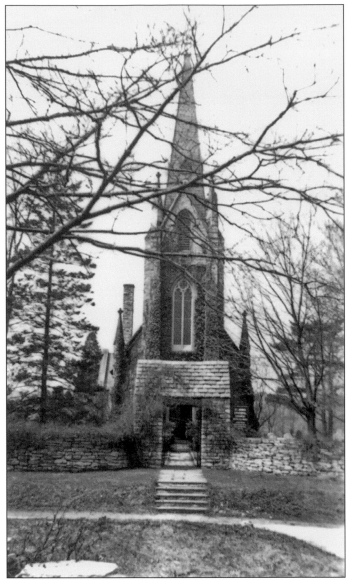

St. John's in the Valley Episcopal Church was founded in 1800 and built in 1816 with funds raised from a lottery. The congregation held services in a schoolhouse that stood across the street from the church location today at 3738 Butler Road in Glyndon. On Christmas Day in 1867, a fire destroyed the church. A new English Gothic church was designed and constructed by Joshua Shorb of Westminster. The cornerstone was relaid on August 17, 1869. The traditional Blessing of the Hounds takes place at St. John's Church every year at Thanksgiving. (Photograph by Louise Bland Goodwin.)

ON THE COVER: World-renowned pictorialist A. Aubrey Bodine, with skill and artistic sensibility, captured the essence of Baltimore County's love of all things equestrian. A meet for a local foxhunt is shown in this 1930 photograph. It takes place at Knoebel's Corner, where Dulaney Valley Road intersects with Manor Road. (Photograph by A. Aubrey Bodine, © 2005 Jennifer B. Bodine, courtesy of www.aaubreybodine.com.)

IMAGES
of America

BALTIMORE
COUNTY

Gayle Neville Blum

ARCADIA
PUBLISHING

Published by Arcadia Publishing
Charleston, South Carolina

Printed in the United States of America

Library of Congress Control Number: 2009923313

For all general information contact Arcadia Publishing at:
Telephone 843-853-2070
Fax 843-853-0044
E-mail sales@arcadiapublishing.com
For customer service and orders:
Toll-Free 1-888-313-2665

Visit us on the Internet at www.arcadiapublishing.com

This book is dedicated to my daughter, Stella, for her contagious enthusiasm and creative inspiration.

CONTENTS

ACKNOWLEDGMENTS

I would like to extend my heartfelt appreciation and gratitude to all those who helped make this book become a reality. Foremost, I want to acknowledge the expertise and guidance of Jason Domasky and Richard Parsons, keepers of the Baltimore County Public Library Photographic Collection, whose knowledge and dedication were an invaluable resource. Likewise, Kevin Clements of the Baltimore County Historical Society and Doris Hoffman of Reisterstown's Historical Society generously contributed invaluable assistance that is reflected between the lines and behind the images of these pages. Most especially, I thank my family and friends who provided understanding, assistance, and motivation, making this book possible.

Unless otherwise noted, all images appear courtesy of the Baltimore County Public Library Photographic Collection.

INTRODUCTION

Early colonists of the 1600s journeyed to Maryland in hopes of enjoying religious freedom and even more so economic opportunities. George Calvert, the first Lord Baltimore, was a devout Catholic who had experienced prejudice at home and in the colonies, particularly Virginia. Impressed and inspired by the bountiful New World, George asked King Charles I for a grant of land north of Virginia. King Charles I not only granted Lord Baltimore his request, he enhanced it by giving him unparalleled power and privileges along with it. Lord Baltimore established Maryland's charter to promote religious tolerance by providing that Maryland would be a Christian colony. This gave Catholics, unpopular at the time, and other Christian denominations the freedom to openly worship without affording special privileges to the Anglican Church, the official Church of England. In 1649, the Act Concerning Religion mandated that any person calling another person "any name or term in a reproachful manner relating to matters [sic] of religion" would have to "forfeit and lose the sum of ten shillings sterling." This new law promoted religious tolerance and resulted in a variety of Christian groups building churches in which to worship. Colonists of Baltimore County, most of whom were Protestant, had no resources to attract clergyman accustomed to a comfortable lifestyle. Religion remained a divisive force among the colonists, and control eventually reverted back to the Protestants.

Lord Baltimore gave many enormous land grants along the Chesapeake Bay to his friends or loyal followers. Many others received grants from the original Lord Baltimore's descendants, who were anxious to see Baltimore County settled so they could collect quitrents. These early pioneers were typically poor; many were indentured servants. Colonists settled along the waterways of Southern Maryland during the early 17th century. They planted tobacco, which drained the soil of nutrients and caused the streams to become clogged with sediment. Trapping beaver became more lucrative, so colonists moved inland, clearing the land and changing the ecological landscape with them.

The migration of colonists into what is now Baltimore County was a slow process originating sometime in the 1650s. Although no exact date is recorded, we know Baltimore County was established prior to 1659 because on January 12, 1659, a writ issued to a county sheriff authorized an election to be held so the citizens of Baltimore County could choose representatives or burgesses for the next session of the Maryland Legislature. Originally the borders of Baltimore County extended far beyond the boundaries known today and included present-day Cecil and Harford Counties, parts of Anne Arundel, Howard, Carroll, and Kent Counties, Baltimore City, and even part of Pennsylvania. This large and expansive county was hard to govern and often posed a hardship for citizens needing to travel to the county seat to conduct business. Over the ensuing years, Baltimore County was chiseled down into a more manageable area with defined boundaries formed as a result of these other jurisdictions becoming established in their own right.

As colonists migrated into the vast wilderness, they entered a perilous land. The woods were home to wolves, bears, bobcats, and cougars. It was also the hunting grounds of the hostile Susquehannough Indians, relatives of the northern Iroquois Nation. Few settlements existed in Baltimore County until the 1690s for fear of Native American attack. The Susquehannough Indians had significant impact on early colonial migration in Baltimore County. In response to attacks, the colonial government entered into a treaty with the Susquehannoughs in 1652; however, fighting continued with both them and the Seneca Indians until the 1670s, when

a combination of war and smallpox diminished their power. The Shawnee Indians settled in Baltimore County between 1670 and 1710, but they too were reluctant to leave and make room for the white settlers migrating inland. It was not until the late 1700s that colonists could settle without fear of attacks by Native Americans. Ironically, it was the Native American trails that facilitated colonial migration into the dense forests of Baltimore County. In 1666, the General Assembly passed a law ordering the counties to widen paths and build roads, enabling horses and eventually wagons to traverse them.

In the early 18th century, Baltimore County consisted of farm folks scattered in small towns with few houses of worship or schools. Many thousands of acres of unpatented land remained available for ambitious settlers, but fewer than 500 families called Baltimore County home. Many descendants of these early colonial families occupy the area today: the Worthingtons, Merrymans, Carrolls, Ensors, Zinks, Traceys, Bosleys, Woodens, Wisners, and Ridgelys. The first homes were meager log homes constructed of hickory or oak cleared from the forests. The logs were notched, fitting tightly together without use of nails. Since colonists depended on fire for light and to keep warm, their homes were always at risk of burning down. Soon stone homes on small estates sprung up, affording more protection against fires. These estates were improved with barns, smokehouses, springhouses, and summer kitchens. Farming was the main industry, with tobacco being the main crop, even serving as currency. Soon farmers shifted to wheat production, which was easier to ship from nearby Baltimore Harbor to demanding overseas buyers. The profitability of farming drove the dispersion of the rural population.

In 1731, Baltimore County's economy became more varied as investors started building iron furnaces to supply the British market with pig iron. The latter half of the 18th century in Baltimore County was distinguished as a period of rapid growth and development. During the Revolutionary War, Baltimore County supplied flour and necessities to French and American armies. The rise and fall of Baltimore County's splendid topography allowed rivers to descend into powerful currents and falls that easily powered milling operations. In the north county, paper mills prospered and towns flourished around taverns and country stores. Artisans and skilled craftsmen gravitated toward these towns for work. Gristmills along the streams of Baltimore County supplied early settlers with grains; surpluses were sold and shipped to outside markets. Many people settled in the towns built up around the mills that employed them. The growing population of Baltimore County benefited from improved roads, making it easier to transport tobacco, corn, and wheat to markets at home and overseas from nearby Baltimore Town, an emerging economic center and bustling port city. Travel by horse, buggy, or stagecoach was slow and uncomfortable. In the late 1700s, Baltimore County constructed turnpikes with gates that allowed passage after paying a toll. Private turnpikes also expanded opportunities to increase commerce and provide for people to travel. In 1828, Baltimore County benefited from the first line of the Baltimore and Ohio Railroad (B&O) that ran between Ellicott Mills and Baltimore. Travel by train was significantly faster and more comfortable. Horses pulled the first trains with wheels mounted on the tracks; starting in 1830, trains were powered by steam. Railroad companies encouraged travel by building recreational areas in the counties. Improved transportation facilitated diversified industries. No longer just a farming community, Baltimore County boasted iron furnaces that supplied iron to the British during the French and Indian War and produced critically needed ammunition during the American Revolution. Timbered trees from Baltimore County's dense woodlands fueled the iron furnaces and supplied the shipbuilding industry in Baltimore Town. Marble mined in Texas and Cockeysville was used to build the Capitol extension in Washington. Numerous quarries located in Baltimore County's valleys produced limestone used in farming and construction. Southwest of Reisterstown were widespread beds of chrome ore used to produce chrome throughout America. Granite from the Waltersville (renamed Granite) and Fox Rock quarries, located in the Patapsco Valley of western Baltimore County, provided building material for many projects.

Throughout its compelling history, Baltimore County has ridden a wave of opportunity, always expanding and improving its industries and promoting its resources while leaving behind a legendary tapestry of prosperity.

One

EARLY ON

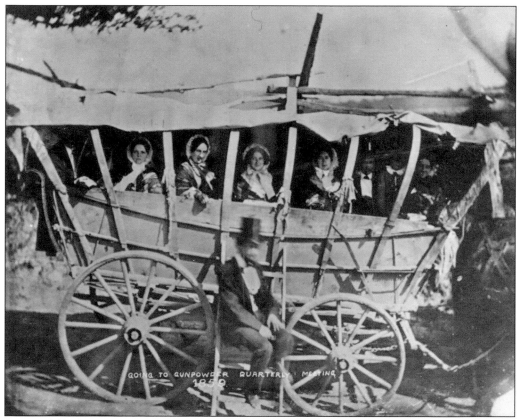

Respectfully dressed in top hats and bonnets, Quaker men and women go to a meeting at the original Gunpowder Meeting House in 1859. Quakers had organized monthly religious meetings in Baltimore County since 1739. Note the ladder used for mounting the horse-drawn wagon with canvas roof. The New Gunpowder Friends Meeting House is located on Quaker Bottom Road in Sparks.

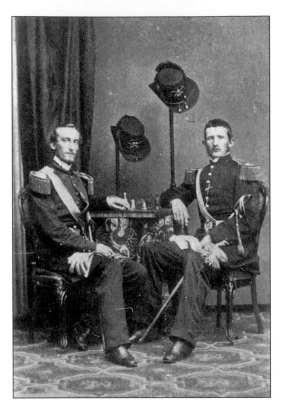

This Civil War–era photograph was taken in 1861 of Capt. Charles Ridgely (1830–1872), left, of Hampton and John Merryman (1824–1881), right, of Hayfields; both are dressed in the uniform of the Baltimore County Horse Guards. Southern-sympathizing members of the Horse Guards wore badges that proclaimed "Old Maryland Line" and "Death Before Dishonor." Captain Ridgely's son, John, inherited his father's Hampton estate at the young age of 21.

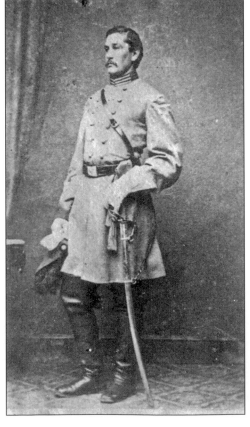

Confederate Cavalry Raider Col. Harry Gilmor called his family's mansion home by the name of Glen Ellen. Glen Ellen was purchased by Baltimore City as part of its Loch Raven Reservoir project. Gilmor's Cavalry was responsible for burning Ishmael Day's house in Fork. In the 1880s, Harry Gilmor served as Baltimore's chief of police.

William Meekins, a stern-faced young Union army soldier during the Civil War, is shown in this 1860s photograph. Other members of his Woodlawn family were active in the Underground Railway. Many Baltimore County families, including the Emmarts, Zieglers, and Zimmermans, were Confederate sympathizers. It was not unusual for Baltimore County families to experience split loyalties during the war.

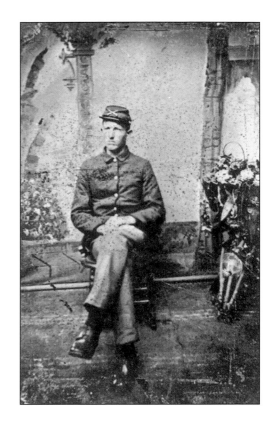

This persuasive 1860s advertisement recruiting Union army soldiers appeared in the *Baltimore American* during the Civil War. Prospects were enticed with pay, rations, bounty land, extra pay, and a $100 bounty when discharged. Privates were promised $13 per month pay with good board and medical attendance.

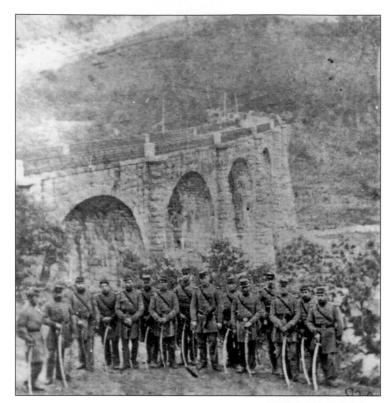

Uniformed officers and enlisted men from Cook's Battery and the Boston Light Artillery pose in front of the Thomas Viaduct at Relay during the Civil War. The view is from the Baltimore County side of the Patapsco River. (Courtesy of Patapsco State Park; photograph by E. and H. T. Anthony Company, New York, between May 6 and June 13, 1861.)

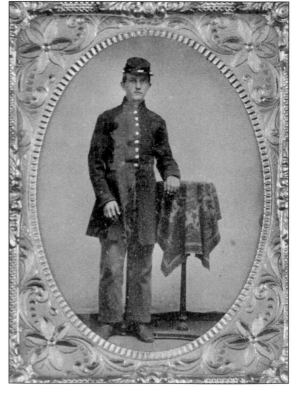

This image taken from a daguerreotype dated 1861 shows young 17-year-old Jacob Ruth Tucker (1846–1926), who won the Congressional Medal of Honor for bravery at the Battle of Five Forks in 1865. Jacob, one of nine children, was a bell maker who joined the Union army and carried the flag during the battle known for breaking the backs of the Confederates.

Archibald Harrison Davis, a Union army soldier from Towson, proudly poses in full uniformed attire for a c. 1861 studio portrait. Archibald's two brothers joined the Confederate army. It was not unusual for families in the Old Line State to be divided in their loyalties.

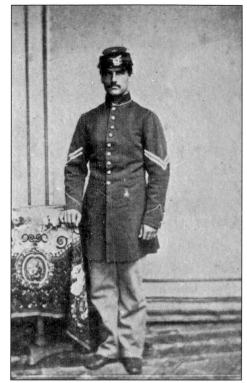

Veterans of the Civil War share camaraderie around a potbellied stove at the Confederate Soldiers' Home on Reisterstown Road in Pikesville. The home, originally a federal arsenal, was opened in June 1888. It closed in October 1932, eventually becoming the headquarters of the Maryland State Police.

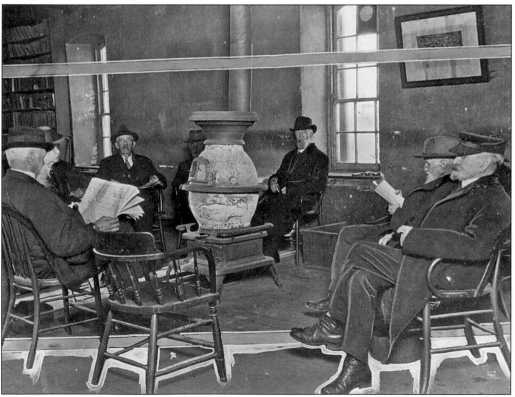

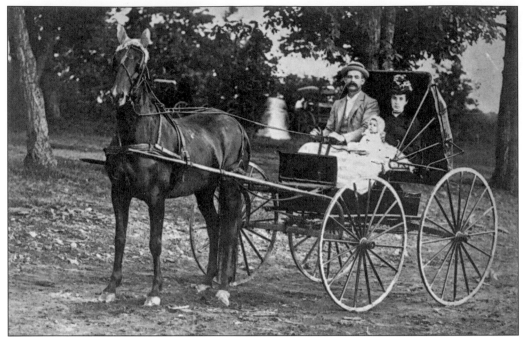

John and Minnie Gore with baby Edda head for the Pine Grove United Brethren Church picnic on July 19, 1892, in a one-horse trap. Minnie's grandfather Jesse Hoshall Sr. fought in the War of 1812, and her other grandfather, also named Jesse, fought in the Revolutionary War. (Photograph by P. S. Weaver Studio, Hanover, Pennsylvania.)

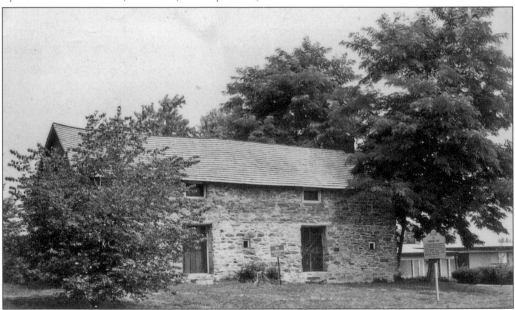

Fort Garrison, the oldest building in Baltimore County, was constructed around 1695 as the headquarters for mounted rangers to look out and patrol the area from the Patapsco to the Susquehanna, helping to keep colonists safe from Native American attacks. It was a remote building situated 9 miles from the nearest colonial inhabitants. The 1975 image shows the fort in its original restored state. (Photograph by G. W. Fielding.)

Two

THE GENTRY

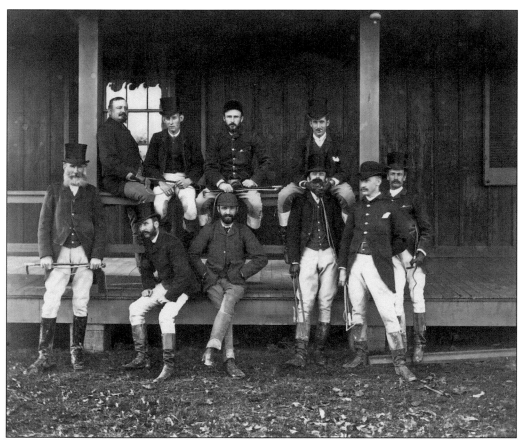

Members of the Elkridge Fox Hunting Club at George S. Brown's Ducking Club House in Back River are identified here, from left to right, on November 29, 1883: (first row) George S. Brown, Cary McHenry, unidentified, Fred Shriver, Frank S. Hambleton, and Joseph H. Voss; (second row) John Gill, Harry Harwood, Alexander Brown, and T. Swann Latrobe. (Photograph by Prof. H. A. Rowland.)

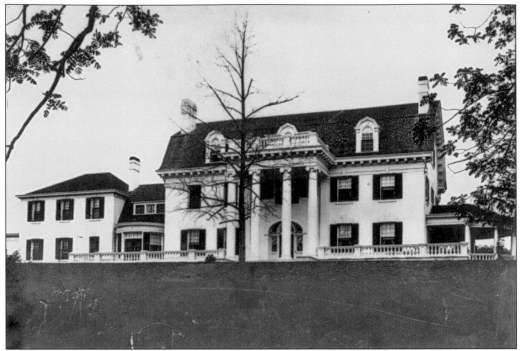

Mensana, also known as Venture and Bally Dugan, sits at 1718 Greenspring Valley Road around 1905. The home, built in 1905 for Edward F. Burke by contractor Israel Owings from a design by James A. Darrach, is used today as a chronic pain facility. (Photograph by a *News American* photographer.)

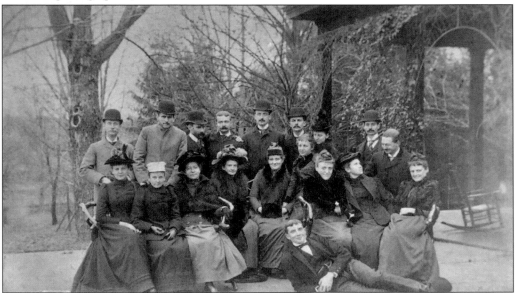

Ladies and gents strike an elegant pose on Thanksgiving Day, November 17, 1890, at Burnside Farm. The following are identified but not specifically located: (first row) Mathilde Keyser, Nancy Fisher, Tayloe Goodwin, Sallie Fisher, Bessie Shoemaker, K. Harrison, Adelaide Gary, Susan MacKenzie, Elizabeth Turnbull, and Ned Shoemaker (lying on his side); (second row) W. Wetherall, William Hodge, Alex Larned, Morris Whitridge, Gordon Hayes, H. Wilson, and Richard White.

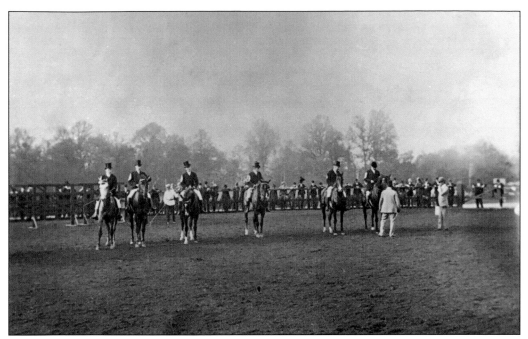

A *c.* 1900 photograph shows members of the Elkridge Hounds gathering near the kennels before a foxhunting meet. In 1919, the Elkridge Fox Hunting Club and two members joined together to purchase a 307-acre farm in Timonium called Long Quarter, located at Dulaney Valley and Pot Spring Roads. The club later moved to Harford County.

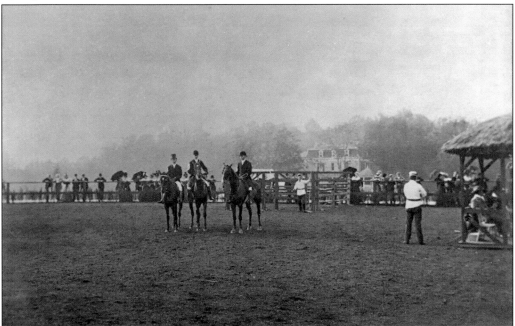

Members of the Elkridge Hounds are waiting atop their mounts near the kennels of the Elkridge Fox Hunting Club before a meet. The Elkridge Hounds had roots in the Baltimore Fox Hunting Club. Foxhunts were popular with the early colonists; foxhunting clubs formed soon after the Revolution.

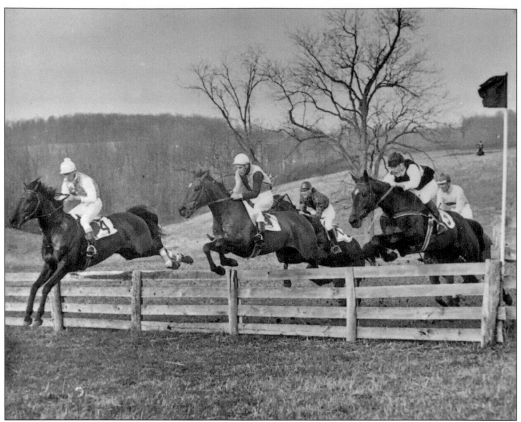

At the Maryland Hunt Cup, unidentified riders in the 1950s or 1960s easily clear a drop fence where the landing side is lower. The first Hunt Cup was held in 1894 when members of the Elkridge Fox Hunting Club competed against members of the Green Spring Valley Hounds in a timber race.

Members of a crowd of spectators look on from the hillside during a Maryland Hunt steeplechase race in the 1930s. The first Maryland Hunt Cup was run in 1894. The steeplechase takes place during the spring in Worthington Valley. (Photograph by a *News American* photographer.)

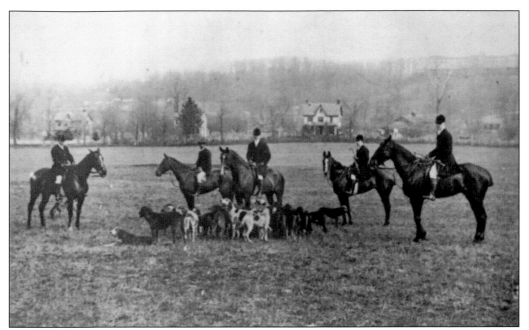

This early-20th-century photograph shows mounted Green Spring Valley Hunt Club members with their hounds on the grounds of Chattolanee. They are, from left to right, Redmond C. Stewart, Plunkett Stewart, Frank Bonsal, Carroll Brown, and George Keyser, the groom.

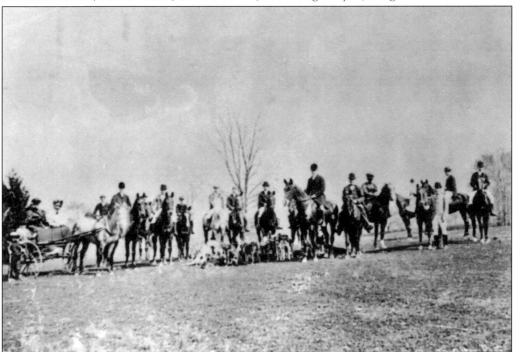

The Green Spring Valley Hunt Club is shown here at a c. 1900 meet at Cliffeholme, the Stewart country estate. Redmond C. Stewart and friends established the club in 1892. The club later moved its quarters to the Ten Mile House on Reisterstown Road. In 1925, the Green Spring Valley Hunt Club found a permanent home at Stamford, 1784 Mantua Mill Road.

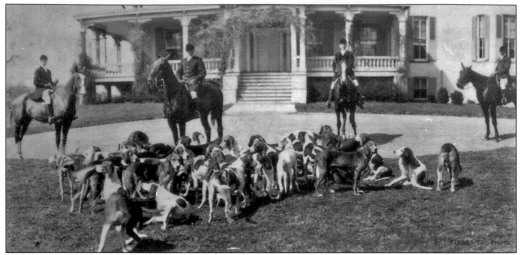

Around 1900, the Master of the Fox Hounds and the Whippers-in oversee the hounds outside and in front of Cliffeholme, the summer home of C. Morton Stewart in Green Spring Valley. The Whippers-in assist in controlling the hounds by encouraging them forward or turning them back to the huntsman.

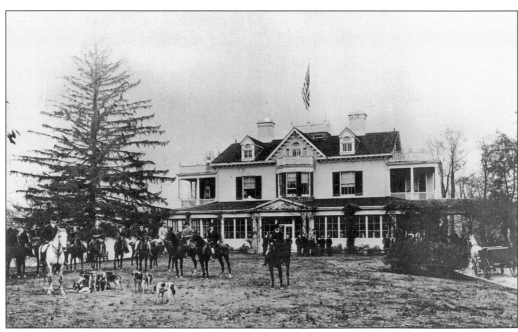

Hounds and huntsmen of the Elkridge Fox Hunting Club gather with Edward A. Jackson, Master of Fox Hounds (1899–1909), in front of Llewellyn on West Lake Avenue around 1899. The property, by then called Windy Gates, was subdivided in the late 1980s by Martin P. Azola.

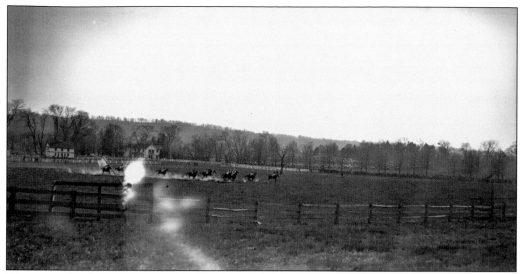

They are off and running at the Maryland Grand National on April 17, 1921. The Grand National is a demanding 3-mile timber race that was begun in 1898 by men who were too young to enter the Maryland Hunt Cup. (Photograph by William C. Kenney.)

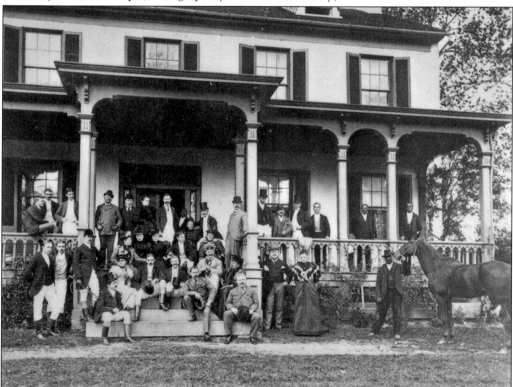

Members of the Elkridge Fox Hunting Club pose on the porch of Mr. and Mrs. W. S. G. Williams of Long Green Valley in Hydes around 1893. Mrs. Williams, the former Belle De Ford, was the daughter of Thomas De Ford, a prominent and wealthy Baltimore merchant. The property later became part of the Boordy Vineyards Estate. Spinster, the horse on the right, was a favorite hunter of Charlotte Williams.

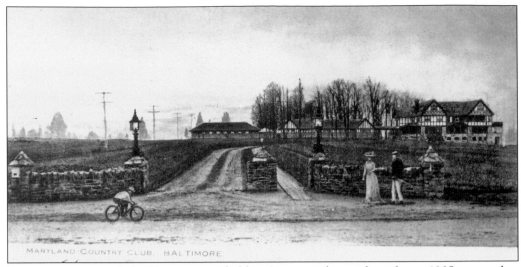

This 1890 Tudor-style building surrounded by 13 acres is depicted on this *c.* 1905 postcard as the home of the Maryland County Club. Originally home to the Baltimore Bicycle Club, it was acquired by the Maryland Country Club in 1897. The building was destroyed by fire in 1924. It is shown on the 1915 Bromley Atlas as being situated on the west side of Park Heights Avenue between Ford's Lane and Strathmore Avenue. In 1957, the Har Sinai Synagogue was built on the site of the old Maryland Country Club at 6300 Park Heights Avenue.

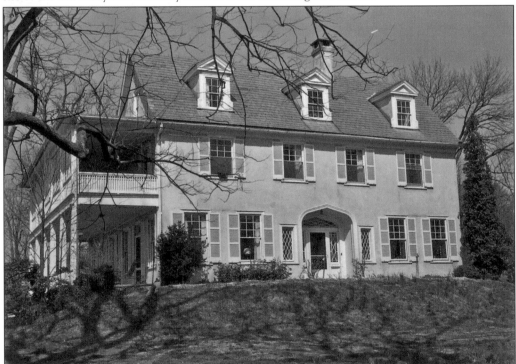

The Caves in Owings Mills was built around 1710 on part of the original 3,000-acre tract of land patented by Charles Carroll. The spacious stone and stucco Colonial-style home (pictured here around 1975) is situated in a pastoral setting off Greenspring Avenue. (Photograph by G. W. Fielding.)

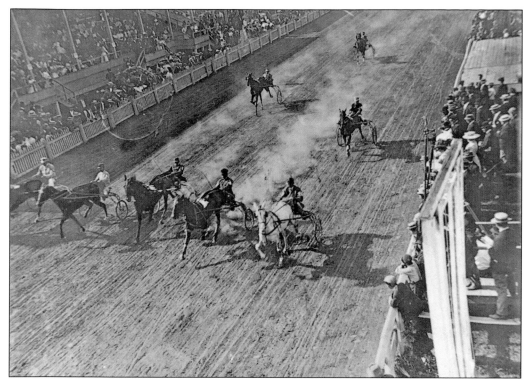

Trotters race down the stretch in a sulky race at the Maryland State Fair in Timonium on September 8, 1908. Harness racing took hold in the mid-1800s, and by the late 19th century, it was one of the most popular sports in America. (Photograph by a *Baltimore American* photographer.)

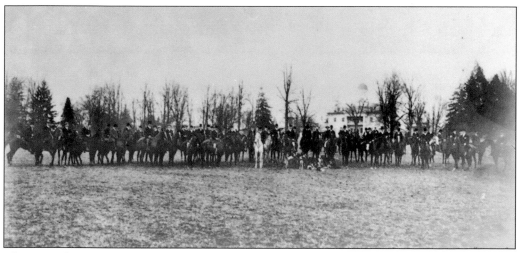

This 1913 photograph captures the joint meeting of the Elkridge and Green Spring Valley Hounds at the Hampton Mansion, visible in the rear middle distance. The entire meet is shown on the front lawn of the Mansion, historically known as Hampton Hall. It was built between 1783 and 1790 for Capt. Charles Ridgely (1733–1790). Hampton was one of the largest plantation farms in Maryland and was owned and managed by the Ridgely family for over 200 years.

Sara Wilmington McCleskey Merryman ("Willie") relaxes on her front lawn with her dog lying at her feet. Mary Neilson stands poised behind the three children while Anna B. Merryman sits astride her horse. A groom controls a horse to the left, and a servant stands poised in the back center. The house was later moved to the intersection of Padonia Road and Interstate 83. The photograph dates to the early 20th century.

Bacon Hall, located at 16300 Cedar Grove Road in Sparks, is reputedly the Nicholas Merryman house recorded on the 1798 federal tax list and is believed to date back to around 1790. The home sits on part of the original 1,036-acre "Bacon Hall" land grant surveyed for Nicholas Merryman Sr. in 1772. During the Civil War, the house was neglected but has since been beautifully restored.

Regulation Farm on Western Run Road was formerly known in the 1770s as the Abraham Scott Jr. house. This view shows the rear garden facade. Frank LaMotte owned the home in 1975. LaMotte Company is a worldwide distributor of test kits for chemical analysis.

The Milton Inn at 14833 York Road in Sparks was once the Milton Academy or "Lamb's School." John Emerson Lamb and his brother, Eli, started the school in 1847. Eliphalet Parsons, who relocated the school to Baltimore City around 1895, acquired the property after the Civil War. John Wilkes Booth was a student at the Sparks school in the 1850s.

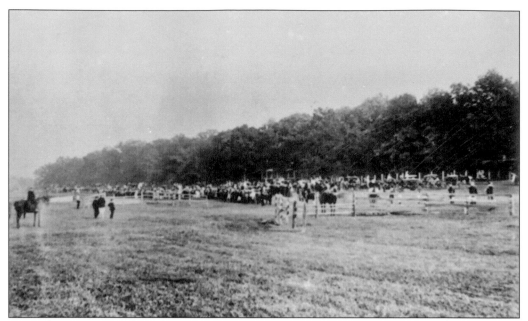

Mrs. John McHenry rides Johnny Miller at a late-1890s show at the Green Spring Valley Hunt Club. The scene takes place in front of the old clubhouse at the jump. Johnny Miller was the winner of the first Maryland Hunt Cup in 1894. He was owned and ridden by John McHenry, president of the Green Spring Hunt Club and a descendent of George Washington's secretary of war for whom Fort McHenry was named.

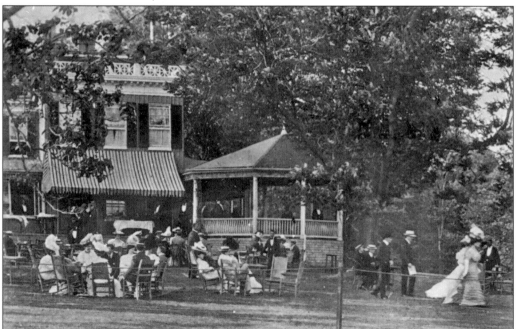

Partygoers enjoy a day in 1906 at the Elkridge Fox Hunting Club, then located at 6100 North Charles Street in the city. The building was once part of Gov. Augustus Bradford's estate known as Montevideo Park. Soon afterward, the club purchased farmland in Baltimore County, more conducive to their needs and without the constraints of the developing city.

Three

COUNTRY LIFE

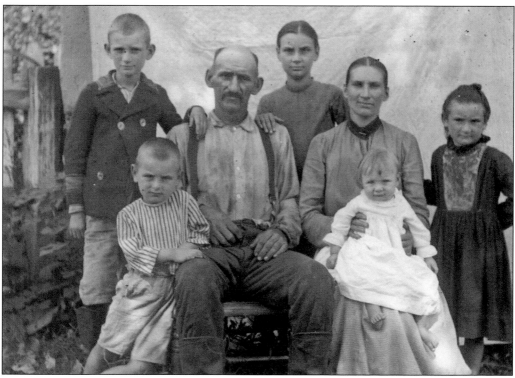

This undated photograph appears to be from the late 1800s or early 1900s and is known to be an image of a rural family located in the Reisterstown area. On close inspection, one can see the setting was outdoors and a drop cloth served as a backdrop. Joshua P. Fitze, a well-known photographer in Reisterstown, took the photograph. (Courtesy of the Historical Society of Baltimore County.)

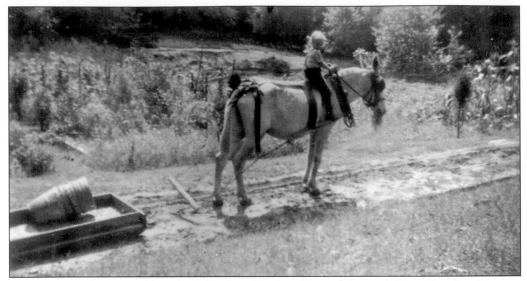

A very young four-year-old Evelyn Bluecher does her share of the work by guiding her horse to pull a sled with harvest baskets on it. Evelyn appears confident in her ability to get the job done, and her horse appears dutifully compliant.

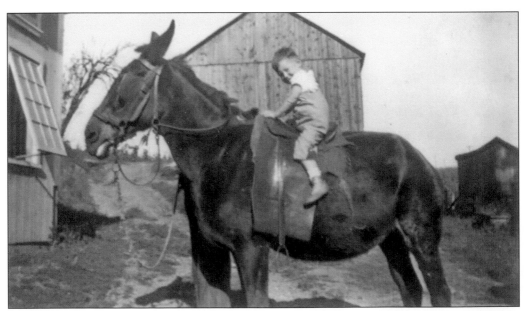

Young Lee Thrasher sits high in the saddle on his mule. In the early 20th century, small family farms were labor intensive and depended on mules and horses to get the job done. This photograph was taken in the White Hall area of Baltimore County in the early 20th century.

Hart Benton Holton's Woodlawn estate, known as the Meadows, was developed on 336 acres in the 1870s. This view shows the property as it appeared in the late 1880s with an enormous barn and outbuildings. Woodlawn Senior High School, the Social Security Administration complex, and part of I-70 occupy the once pastoral site today.

The Davis farmhouse in the agricultural village of Warren is shown in the right middle distance in this 1898 panoramic view. Eventually, the farm was submerged underwater to make way for the Loch Raven Reservoir. (Photograph by Lucia or Alice Davis.)

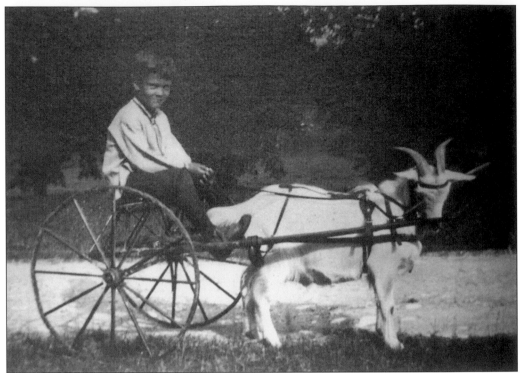

Young Charles Goodspeed Lord (1905–1992) is shown riding his goat cart with Billy in 1910 or 1911. Charles was descended from an early English settler in Massachusetts on his father's side. His father was real estate and stockbroker Henry Murdoch Lord. Goat carriages were used for pleasure and also as a means to teach boys to learn to harness and drive. Studebaker of Indiana, in its infancy, advertised goat carts for sale.

The Baldwins' log cabin guesthouse at Hillside Farm in Warren consisted of a 30-foot-long drawing room, breakfast room, and an attic divided into five or six rooms used as servants' quarters. The Warren Boy Scouts held their meetings in the house for a period of time.

This panoramic photograph shows how the McDonogh School looked in 1886. It was started as a farm school for poor boys. The estate of John McDonogh (1779–1850) funded the school. Col. William Allen, a former Confederate ordinance officer and professor of applied mathematics at Washington and Lee University, was the first principal.

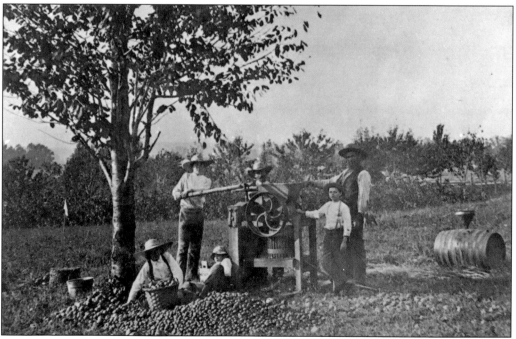

Boys at the McDonogh School in 1886 demonstrate how to make apple cider with a cider press and a pile of fallen apples. Students worked on the farm in exchange for their education, room, and board. The first class in 1873 began with only 21 students.

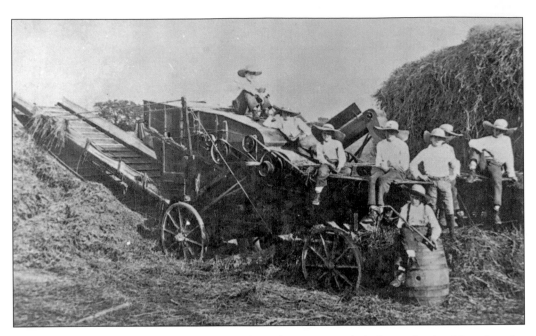

These *c.* 1886 photographs show McDonogh students using a belt-driven loader (above) and a piece of 19th-century steam threshing equipment (below). The school campus covers more than 800 acres. It was established on November 21, 1873, as a semi-military school for orphan boys and evolved into a prestigious coeducational institution. In 1922, McDonogh accepted students who paid tuition, and in 1960, African Americans were admitted. In 1971, the school abandoned military traditions, and in 1975, it became coeducational. McDonogh School is still guided by the original philosophy "to develop moral character, a sense of responsibility, and a capacity for leadership." (Both, courtesy of www.mcdonogh.org.)

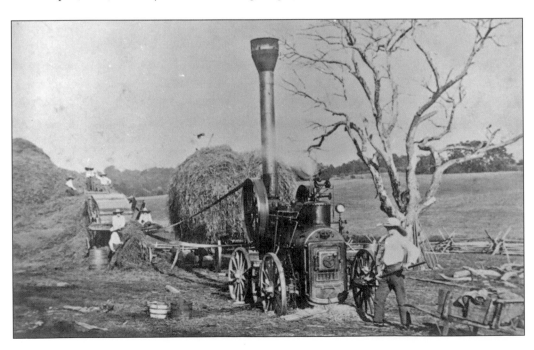

The Rice family is photographed feeding the chickens at the David and Elizabeth Mayes Michael farm known as Sunnie Holme, later called Starrhill, in this early-20th-century image. The farm was located in Woodensburg, which lies between the villages of Reisterstown and Fowblesburg.

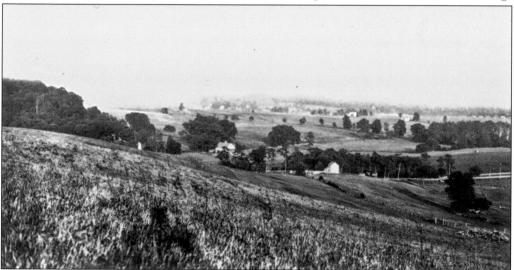

This panoramic view of the valley was taken from the hill at Bonnie Blink Masonic Home in Cockeysville. The beautiful c. 1931 pastoral scene later became the location of the Hunt Valley Industrial Park. (Photograph by Elmer Haile Jr.)

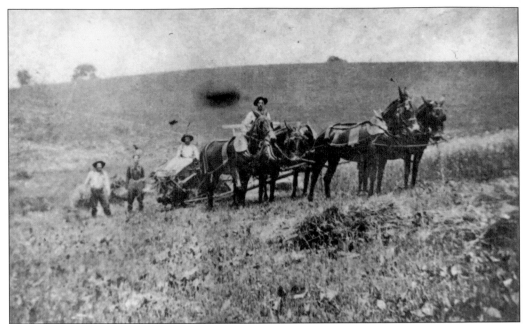

Farmhands stop for the camera with their mule team while harvesting crops in this late-19th-century photograph. The scene takes place near the town of Warren in the Gunpowder River Valley. Warren was later submerged to accommodate the expansion of the Loch Raven Reservoir. (Courtesy of the Historical Society of Baltimore County.)

This Lutherville farm known as Eldon, located at 313 Lincoln Avenue, depicts a typical rural homestead of the 1890s with a tenant house and large barn. The cupola of the main home can be seen at the far left. The home formerly belonged to Francis Corkran. It was demolished in 1965.

William C. Brooks accompanies Charlie, who is riding the horse that pulls the seeder at Brookvale Farm located at 14943 York Road in Sparks in the 1890s. Brooks attended the Milton Academy, now the Milton Inn on York Road, and later became an undertaker.

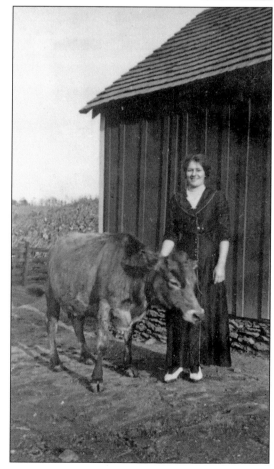

Elva Alban Parrish (1893–1978) proudly poses with her prized cow in this photograph taken around the time of World War I on the Wesley H. Alban farm. The farm was located in the sixth district in northwestern Baltimore County.

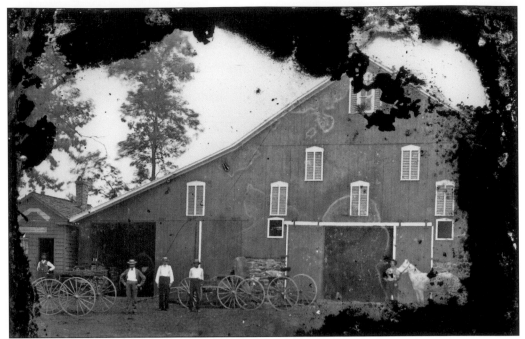

This deteriorating image from a *c.* 1887 glass negative still succeeds in capturing the authenticity of rural farm life in northern Baltimore County despite its compromised condition. The men in the photograph all appear to be wearing straw hats. (Photograph likely by David F. Painter.)

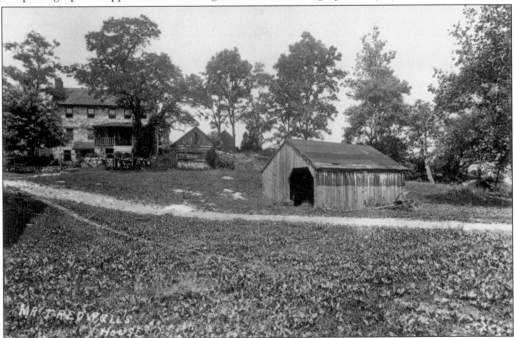

This *c.* 1921 photograph shows the barns, home, and outbuildings of the Hampton estate that were rented to William E. Treadwell (1840–1930). The farm was taken for the second phase of the Loch Raven Reservoir expansion between 1921 and 1922. (Photograph by the city water engineer's photographer.)

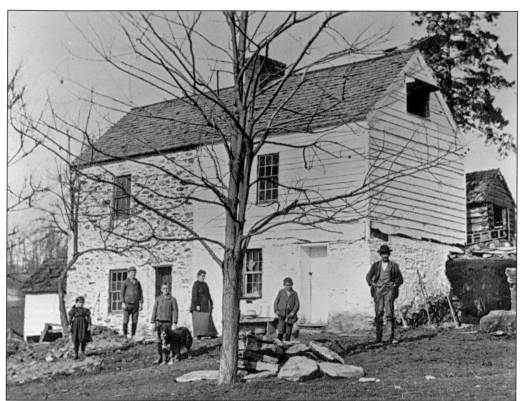

Mr. and Mrs. Smith pose with their children and family dog in this winter scene on January 18, 1903, next to their stone and clapboard home at 12500 Ivy Mill Road in Reisterstown. One of the outbuildings is likely a privy. (Photograph by Joshua Fitze.)

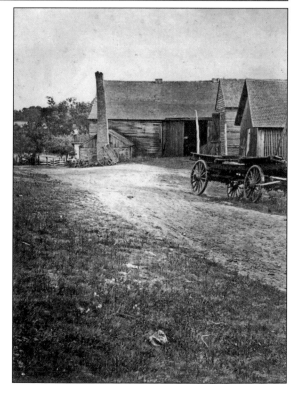

Quaint outbuildings and a wagon are shown on the Wester Ogle estate in Owings Mills in the late 19th century. Dr. William Lyon of Scotland patented the 720 acres of land that Wester Ogle was built on. The tract eventually was enlarged to 2,300 acres.

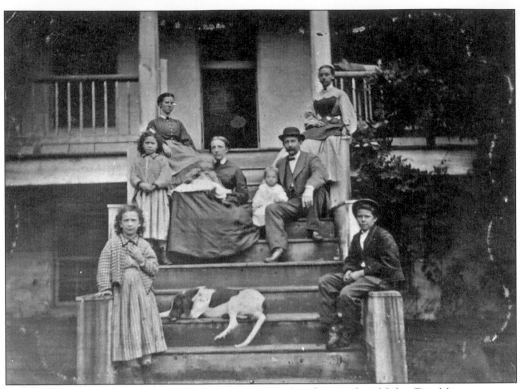

Southern colonel John Franklin
Mahool (1828–1876) sits on the steps
of the Manager's House in Phoenix
with his wife, Fannie Bias Hammond
Mahool, and some, not all, of his
children, including J. Barry Mahool, his
youngest child, who grew up to become
mayor of Baltimore City. The historic
photograph dates to around 1867.

Freddie Parrish, a Woodlawn farmer of
the early 20th century, stands behind one
of Frank Kelly's Peerless steam threshers.

Members of the Hermann family sit outside of their home on Philadelphia Road in Rosedale around 1903. Their home was across the street from the Golden Ring Inn, a business they established. The Hermanns also had a pond that local residents used for fishing, boating, and skating.

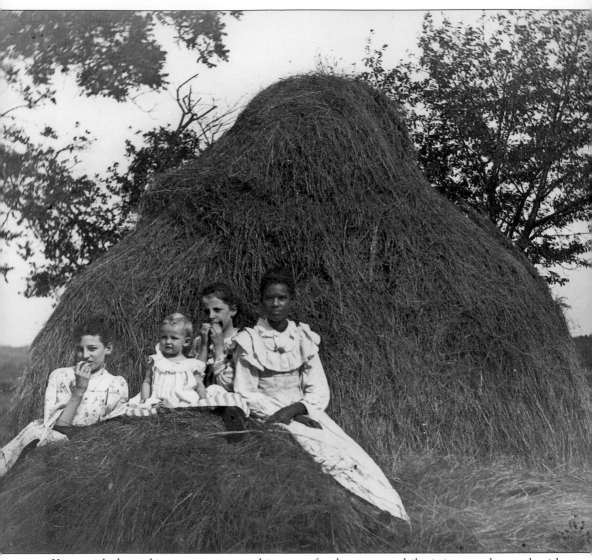

Young girls dressed in pretty summer whites pose for the camera while sitting on a haystack with another much larger haystack looming behind them. The setting takes place at Windsor, the Ball estate, near Catonsville, in the early 20th century. (Courtesy of Peale Museum.)

Four

LOVE OF LEARNING

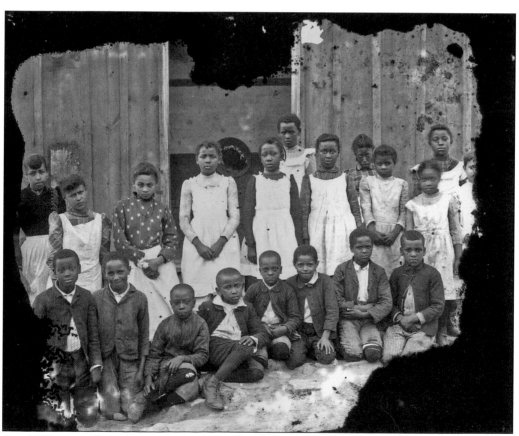

A c. 1890 group of very attentive, serious, and well-dressed schoolchildren pose with their teacher in a school presumably in the Beckleysville area of Baltimore County. All the boys are seated in the first row while the girls are standing together in the back. (Photograph most likely by David F. Painter.)

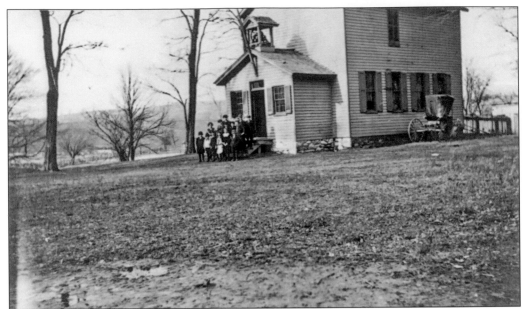

Students of the Mantua Mills School pose on the steps of their two-story clapboard schoolhouse complete with bell tower. The school was on a road leading from Shawan Road to Reisterstown. A carriage is parked on the side of the building, presumably waiting for its occupants. An unidentified photographer took this picture in the 1920s. (Courtesy of the Historical Society of Baltimore County.)

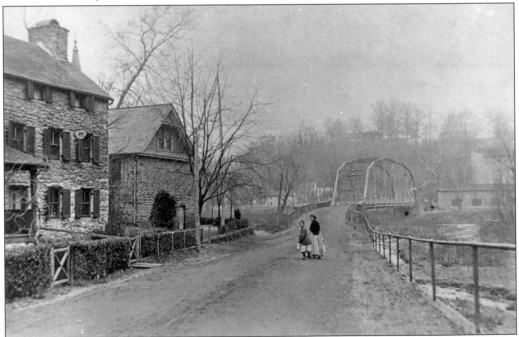

Two girls glance back at the camera in 1909 while approaching the iron Warren Bridge built in 1896. It replaced the wooden bridge that was washed out in September 1895. The back of the stone Warren School is seen at left, next to a stone home seen in the left foreground. (Photograph by a *Sun* photographer.)

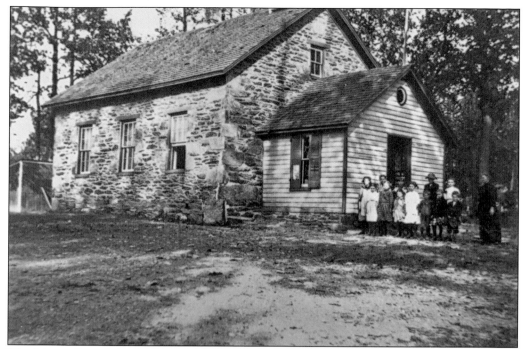

The Mount Etna School was a quaint one-story stone schoolhouse with a clapboard entrance vestibule. The schoolhouse design is that of Thomas Dixon and James M. Dixon. The teacher, seen wearing a long dark dress, stands with her students of varying ages outside of the vestibule in the 1920s. (Photograph by Jennie Jessop.)

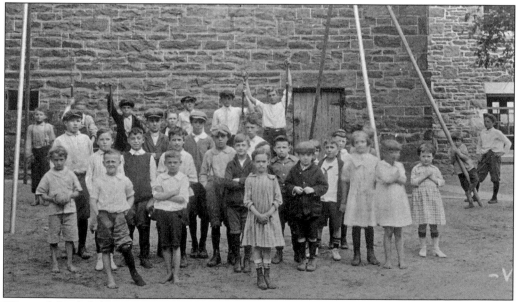

Warren School children pose for a group photograph in the back of their L-shaped stone schoolhouse. A member of the city water engineer's appraisal team captured this image of the children on May 27, 1921, for documentation purposes connected with the Loch Raven Reservoir expansion project. The children, many barefoot, were likely oblivious to the purpose of their pose. (Courtesy of the Historical Society of Baltimore County.)

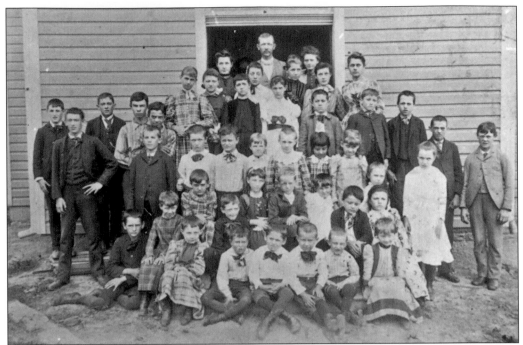

Students and teachers pose outside of the Shane School in this 1890 photograph. The young boys sitting in the first row appear to be wearing knickers and bow ties while complying with the request to sit cross-legged, left over right. The students and their teachers strike a picture-perfect pose. (Courtesy of the Historical Society of Baltimore County.)

Situated at the northwest corner of Mount Zion and Black Rock Roads in the Trenton area lies a residence that previously, as shown in this 1920s photograph, was a Baltimore County school. The school sits up high with a bucolic view of the surrounding farms. (Courtesy of the Historical Society of Baltimore County.)

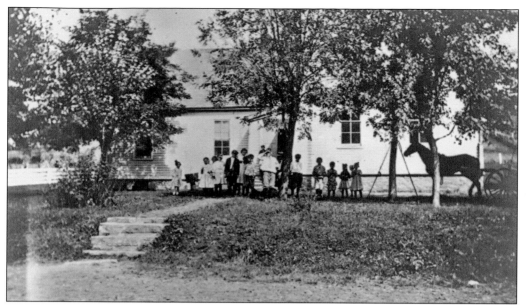

The Butler School, also referred to as the Bellefield School, is located on Western Run Road at Joyce Lane. It was built in 1899 and was closed in 1934. The Butler School consisted of three classrooms rather than the typical one room of the day. This mid-1920s photograph shows students posed outside the clapboard structure with a horse and buggy at the ready. It is now a private residence. (Courtesy of the Historical Society of Baltimore County; photograph by Jennie Jessop.)

This old brick school at Hoffmanville (here in 1927) was previously called Gunpowder Paper Mill School. Hoffmanville derived its name from William Hoffman, the first paper maker in Maryland. He built his first mill on the Gunpowder Falls. (Photograph by May Albright Seitz.)

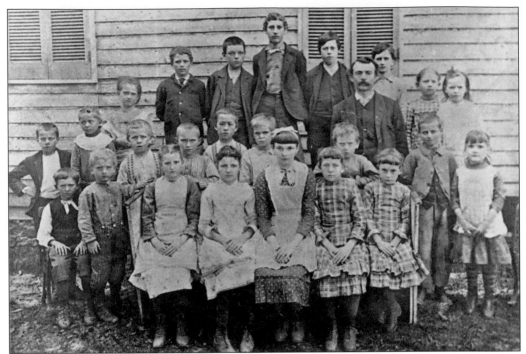

Principal Arthur Crommer and his impeccably dressed students pose outside of the white clapboard Mantua Mills schoolhouse on April 13, 1899. Principal Crommer later became principal of Towson High School after 1909. (Courtesy of the Historical Society of Baltimore County.)

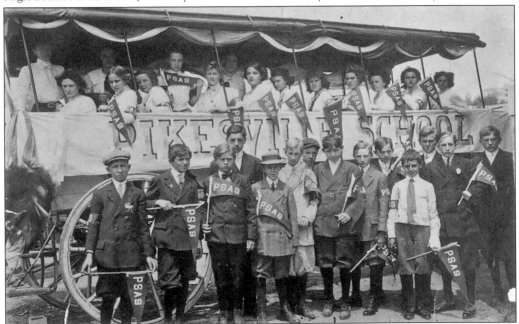

This early-20th-century outdoor group photograph from the Pikesville School shows students displaying school pride as they wave pennants emblazoned with "PSA8." The girls are seated in the horse-drawn wagon while the boys stand in front wearing knickers. It is possible the "8" stood for "8th grade."

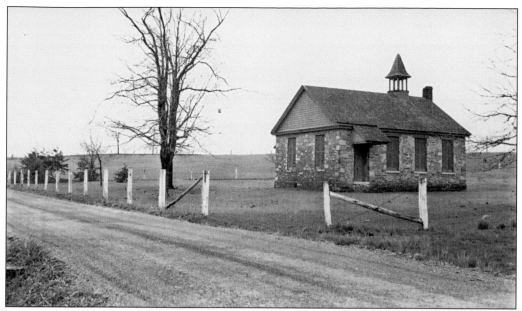

John Hagar built Yeoho School, a one-room stone schoolhouse, in 1881 or 1882 and rebuilt it a year later after a fire on the property. Yeoho School (pictured here in 1939) was located on 120 acres at Stringtown and Yeoho Roads. S. Virginia Akehurst and Eva A. Akehurst attended the school as children, and as adults, they bought the schoolhouse and converted it to a residence. (Photograph by Benjamin H. Engle.)

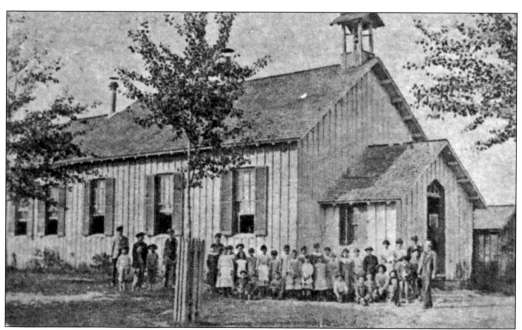

Greenwood School on Long Green Pike was a frame schoolhouse with a bell tower located near the Harford Road intersection. A group of children and their teacher are shown in the early 20th century standing outside the school that lasted from 1862 to 1922. (Photograph by a *Sun* photographer.)

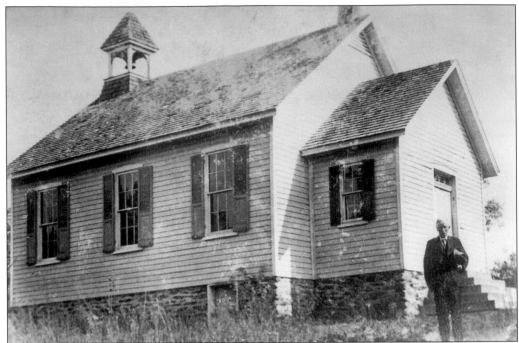

Yale-educated Prof. Joseph Fowler stands in front of Kidd's School at the corner of Beckleysville and Kidd's School Roads. It was built between the late 1890s and 1910. Eventually, the county sold it, making way for the Prettyboy Estates subdivision. The photograph was probably taken in 1927. Professor Fowler taught in this rural one-room school.

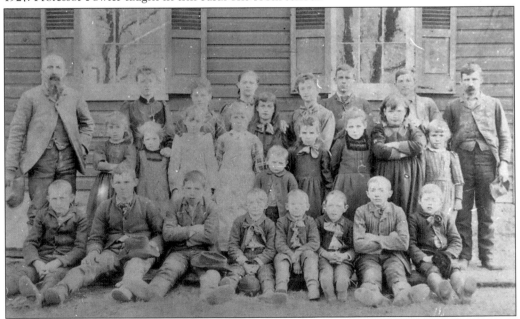

Gill's School operated between 1872 and 1933 at 12112 Garrison Forest Road. This photograph, likely from the 1890s, shows the male students seated on the ground in front with arms folded and the female students standing in the rear. The teachers are posing with their students outside the frame building with shuttered windows. (Courtesy of the Historical Society of Baltimore County.)

The Hebbville School is shown below about 1930. It was also called the Humane School. It was located in the town of Hebbville near Woodlawn. The early photograph at right depicts students and staff in the early 1900s at the Hebbville School all dressed up in their finest clothes. They are assumed to be, from left to right, (first row) unidentified, Horace Harrison, and two unidentified; (second row) three unidentified and Albert Piel; (third row) George Harrison, Christine Harrison, Bertrum Piel, and Belle Heisse; (fourth row) Bertha Baker, John Kirk, and Bessie Reinhold; (fifth row) Henry Liebno, James Heisse (teacher), and Barbara Stauffer.

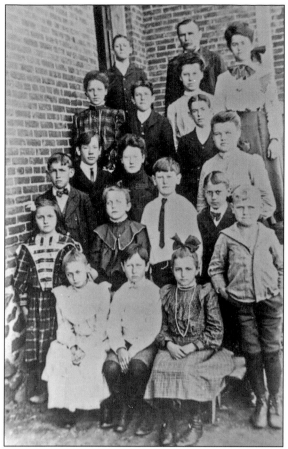

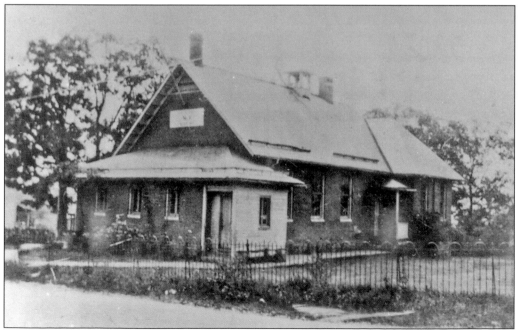

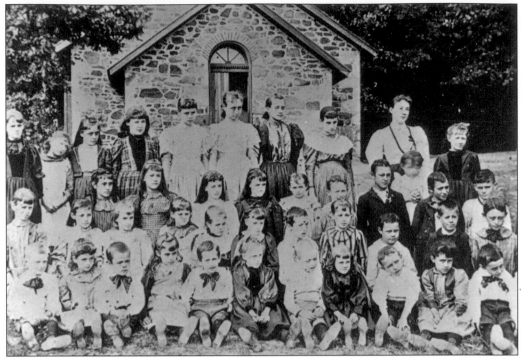

Observe the perfectly posed outdoor photograph of the student body of the Johnnycake School around 1890. They are standing outside of their stone schoolhouse. The school was located on the northeast side of Old Frederick Road at the Rolling Road and Johnnycake Road intersection in Catonsville.

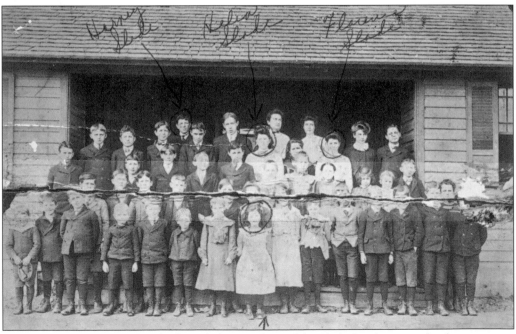

Long Green School's student body includes members of the Slade family posing for the camera in front of their wooden schoolhouse, either between 1895 and 1899 or between 1903 and 1904.

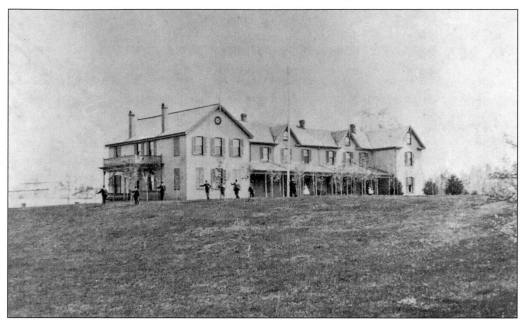

This 1890s image is of St. George's School for Boys in Glyndon. J. C. Kinear was headmaster of the private school. The original building was destroyed by fire on July 15, 1896. This photograph is likely an image of the original school. The 1877 atlas notes a "Boarding School" in the vicinity.

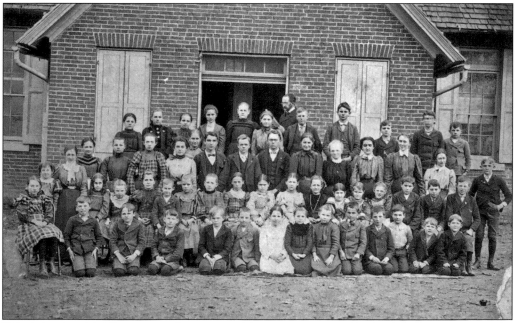

Eklo School on Middletown Road is renowned for pioneering "Rural Life Education" courses under the direction of Principal John Hale from around 1917 to 1921. The teacher in center rear appears to be reading while the c. 1890 photograph of a large student group is being snapped. (Courtesy of the Historical Society of Baltimore County; photograph by P. S. Weaver of Hanover, Pennsylvania.)

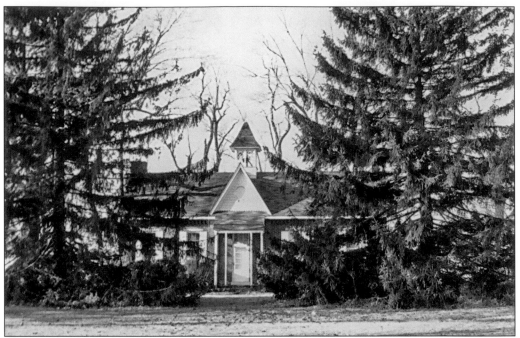

If it were not for the telltale bell tower, no one would guess this enchanting cottage shown on December 27, 1978, tucked under the evergreens was once the Rayville Schoolhouse at 124 Middletown Road. Converting to private homes has successfully preserved many such charming historic schoolhouses in Baltimore County. (Photograph by John McGrain.)

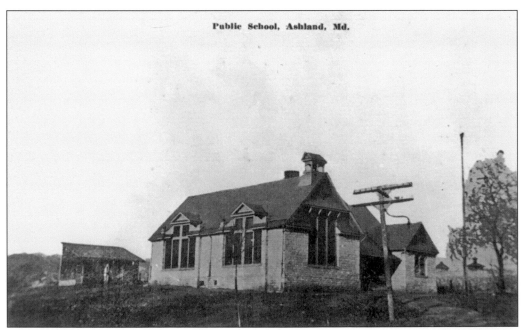

Ashland School, built in 1882, was later converted into a private residence, preserving history for generations. Steve and Donna Stoecklein converted the school into their home at 200 Ashland Road in Cockeysville. This photograph portrays the property around 1909.

The Parkton Village School, located in rural northern Baltimore County and pictured here around 1915, featured a traditional bell tower to call students to school. (Photograph by a member of the James Underwood family.)

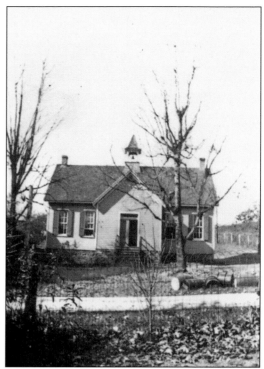

Steve Muller, a young teacher at the Loreley School, retains an aura of command with hand on hip and watch chain tucked in his vest. His pupils dutifully pose for the camera outside their clapboard schoolhouse in this 1912 photograph. The school, located on Philadelphia Road in Loreley, was opened in 1861 and subsequently closed in 1923; thereafter, it was used as a recreation center.

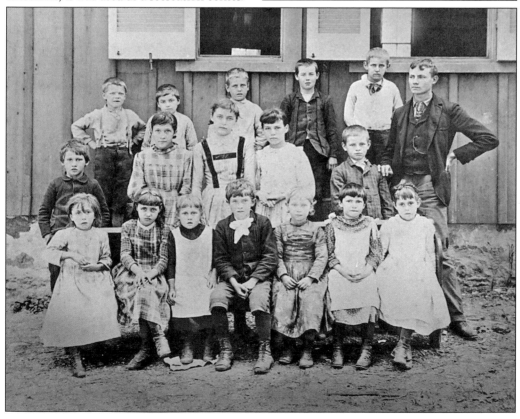

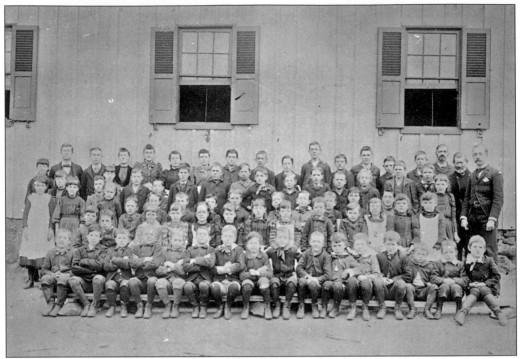

The entire student body posed outside of the Fork School between 1859 and 1922. The wooden clapboard schoolhouse was affectionately known as "Dogwood Academy." It was opened in 1859 and later enlarged because of expanding enrollment. Sometimes it required the services of three teachers. Heavy curtains were used to partition off the one-room schoolhouse to accommodate the need for several classrooms. (Photograph likely by David F. Painter.)

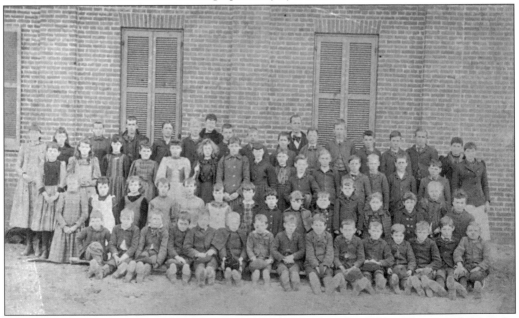

Unidentified pupils pose outside of the Dover Road School in the 1890s. (Photograph likely by David F. Painter.)

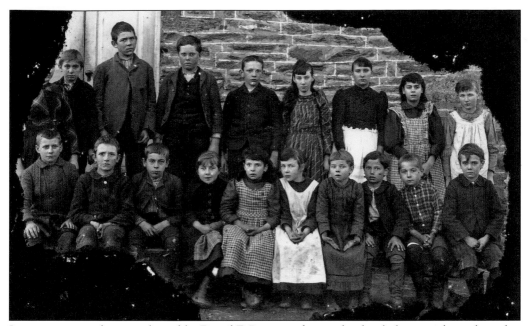

Itinerant group photographers, like David F. Painter, often took school photographs such as this one. Numerous untitled glass-plate photographs were salvaged from his home in Beckleysville. These unidentified pupils in the above photograph gather outside of the rural two-room Dover Road Schoolhouse in the 1890s. The schoolchildren in the image below were likely from a north Baltimore County school. The plate was recovered from the home of David F. Painter. The image is strikingly crisp and captivating in spite of the emulsion loss around the edges. Most of the boys are wearing jackets while several of the girls are wearing pinafores.

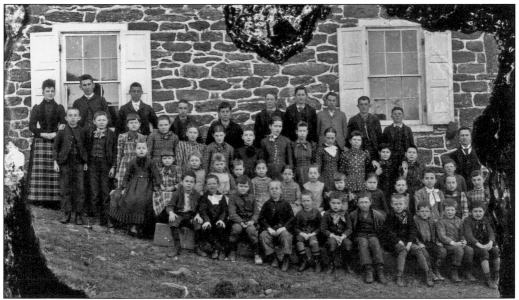

A rather large group of students with what appears to be several teachers pose on the side of their stone schoolhouse flanked with shuttered windows. The students are dressed for the occasion. The c. 1890 photograph was recovered from the home of David F. Painter, a noted school photographer.

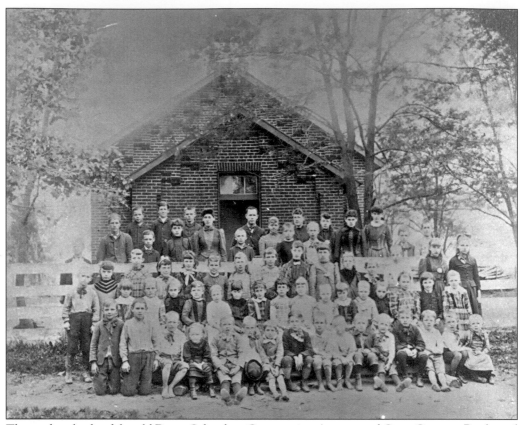

The student body of the old Dover School on Greenspring Avenue and Cross Country Boulevard poses outside of their small brick schoolhouse. The teacher, Dr. Edgar Cordell Powers, stands in the middle of the back row in the late 1880s or early 1890s. (Photograph by David F. Painter.)

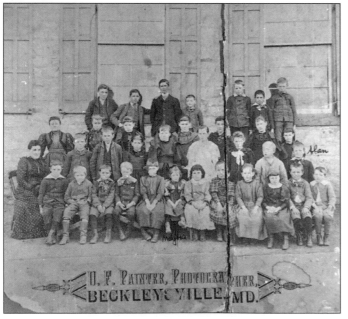

The unidentified teacher and students of Sparks Elementary School sit for the camera around 1890. This became a school for African American children around 1909. The County Board of Education closed the school in 1960 and sold it to the John Huff family, who converted it into a home they named Tujay's Farm. (Photograph by David F. Painter.)

Five

RELIGIOUS ROOTS

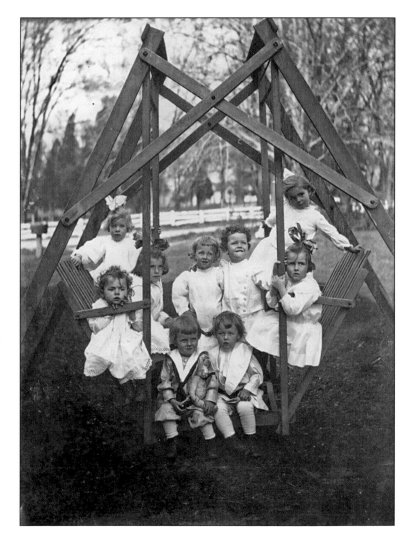

The "Infant Class" of St. Paul's Evangelical Lutheran Church poses prettily in this 1909 or 1910 portrait. The church was built in 1898 on the site of the first Lutheran church in Lutherville and is located at 1611 Kurtz Avenue. (Photograph by Emma K. Woods.)

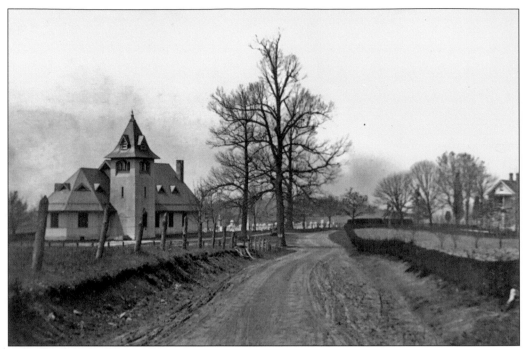

A winding dirt road leads to Chestnut Grove Presbyterian Church on Sweet Air Road in Phoenix back in this 1920s fall vista. The building was erected from 1842 to 1843 after previously holding services in the Long Green Academy from about 1825 until 1843. (Photograph by William C. Kenney.)

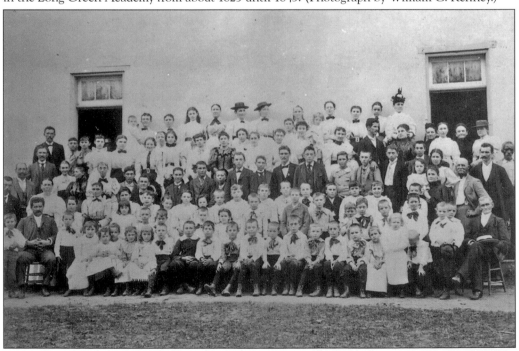

A very large 1895 group of Sunday school students from Chestnut Grove Presbyterian Church, located at 3701 Sweet Air Road in Phoenix, poses with numerous adults, likely teachers. The photograph reflects a wide span of ages. (Photograph by David F. Painter.)

St. Mark's-on-the-Hill Episcopal Church (here around 1880), located at 1620 Reisterstown Road in Pikesville, began with a deed for three-quarters of an acre conveyed to Charles T. Cockey on April 16, 1877, from the McHenry family. The deed stipulated that the site was always to be used as a place of worship or it would revert back to McHenry family ownership.

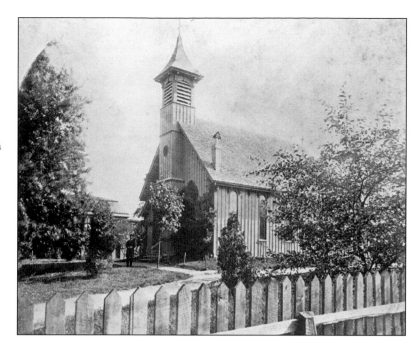

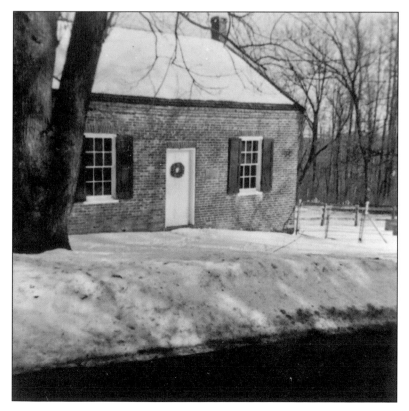

Rev. Jacob Geist was the first pastor of the Geist Reformed Mennonite Church on Geist Road. The simple brick building was constructed in the 1850s. Adjacent to the church, pictured in 1987, is the cemetery. (Photograph by Helen Geist.)

St. Paul's Evangelical Lutheran Church at Chestnut Ridge was established in 1859. A small group of parishioners pose in a field of grasses and wildflowers near the church graveyard. The front and side of the aging church structure form the backdrop of this somber scene captured in a 1930 photograph.

A plain and simple Chestnut Grove Presbyterian Church located at 3701 Sweet Air Road in Phoenix is commemorated in this old 1898 photograph. The church has undergone significant modifications since the time it was first constructed in 1842 to 1843. (Photograph by Alice or Lucia Davis.)

The Hiss Methodist Chapel on Harford Road is shown here in 1904 featuring an impressive steeple. The frame structure was built in 1895 to replace an earlier stone chapel constructed in 1839 and replaced yet again by another structure in 1954 that stands today at 8700 Harford Road in Parkville.

The faithful laid the cornerstone of the Halethorpe United Methodist Church on February 24, 1894, during what was described as a "terrific snowstorm." About 50 people celebrated this event welcoming the first dedicated house of worship in their community. The early-20th-century photograph shows members gathered around the front of the frame structure.

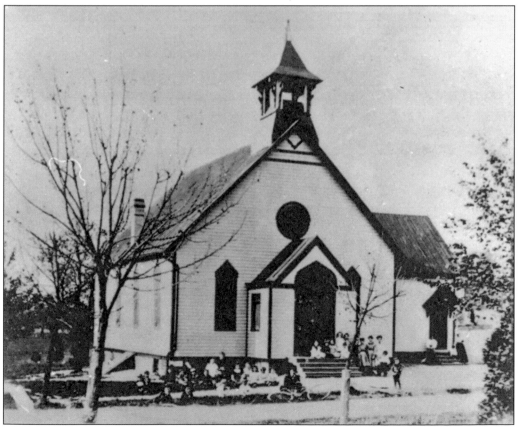

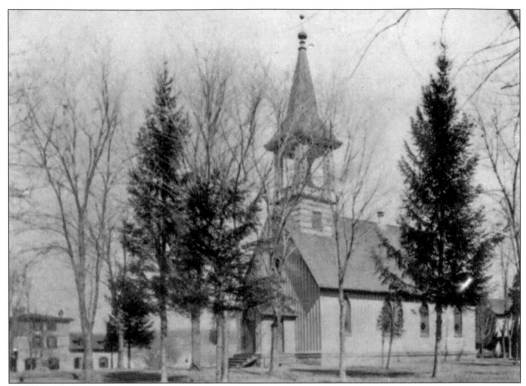

This pre-1898 image depicts the first Lutheran church in Lutherville, which was formed in 1853. The cornerstone of the first church building was laid on July 19, 1856. The house of worship was replaced with St. Paul's Evangelical Lutheran Church, a charming Carpenter Gothic structure built in 1898. The church, located at 1609 Kurtz Avenue in Lutherville, remains today with a thriving congregation. (Photograph by Emma K. Woods.)

Gary Memorial Church in Alberton sits on the Patapsco River at the Baltimore County line. The church was dedicated on February 1, 1880, as the Evangelical United Brethren Church. The public school can be seen in the upper right distance as well as an icehouse in the bottom right foreground. The church was built for the cotton mill town of Alberton, which produced cotton duck for tents, wagons, and awnings.

The Poplar Methodist Protestant Church at 9907 Philadelphia Road in Nottingham Village succeeded the 1866 Jones Memorial Church. This late-19th-century photograph shows the church and some members prior to its demolition sometime in the 20th century. A carriage awaits its occupants at the side of the building. Women preferred this mode of travel to church on dirt roads rather than riding sidesaddle on horseback.

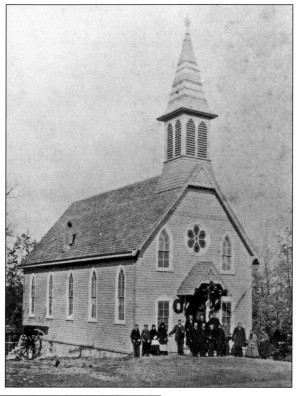

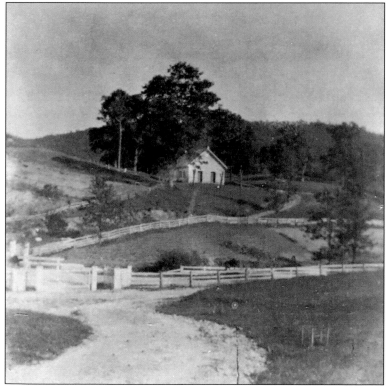

Warren Methodist Church, known after 1910 as Juliet Memorial Church, is seen here in 1898 on its hilltop. The road in front of the white fence veers off at the left to become Warren's Main Street leading to the mill. The expansion of the church seen in later images occurred after the death of Juliet Baldwin with the financial help of her parents. (Photograph by Lucia or Alice Davis.)

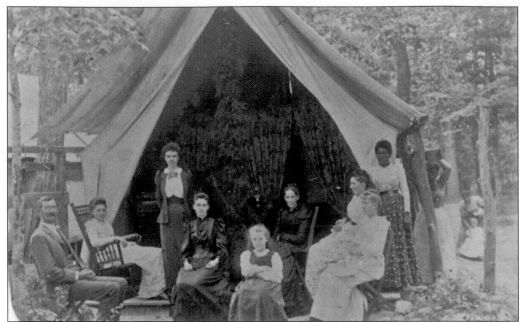

Edgar and Maude Freeland, friends, and a servant pass the time in their tent at Emory Grove in Glyndon around the end of the 19th century. They joined other Methodist members of the Emory Grove Association in renting a tent each summer to participate in religious meetings. At summer's end, tents were dismantled and participants went home. Emory Grove, founded in 1871, was named for Bishop John Emory of the Methodist Church. (Photograph by Hester Ella Stabler.)

The Ames United Methodist Church at 9 Walker Avenue in Pikesville is seen in the right foreground of this 1898 photograph. Wheel tracks in the dirt road lead to the carriage in the distance. The stone structure with a steep-pitch roof was constructed in 1875 by Philip Watts of Pikesville.

Six

YE OLD MILLS

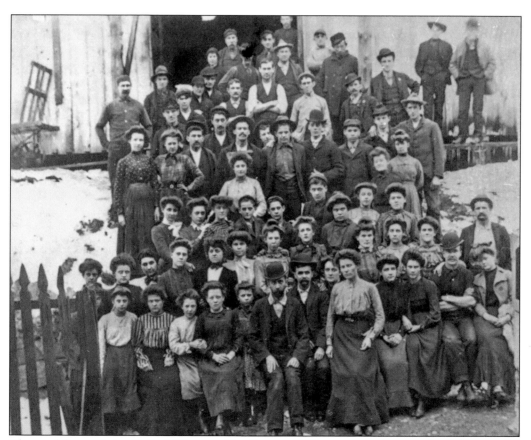

The workforce of the Oella Mill assembles for a c. 1890 company photograph. Oella, on the banks of the Patapsco River, was named after the first woman to spin cotton in the continent of America; Oella was the mother-goddess of the Incas of Peru who taught weaving and spinning. Founded in 1808, Oella Mill was the first textile company to be chartered by the State of Maryland. Surviving fire and flood, the mill was eventually sold at auction in 1887 to William J. Dickey, famous for producing woolens.

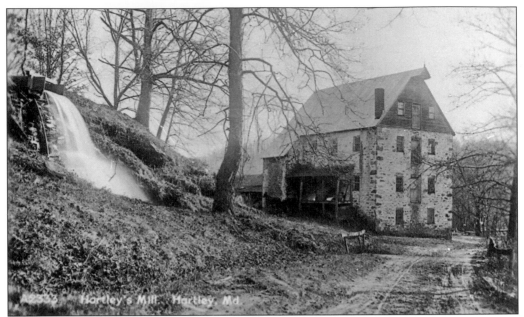

Hartley's Grist Mill, powered by nearby Long Green Run, sits off Hartley's Mill Road in scenic Glen Arm. Phineas Hartley (1824–1894) acquired the property in 1885. The three-story stone with fourth-story frame structure burned around 1923. (From a 1912 postcard by Warranty Company, Rutherford, New Jersey.)

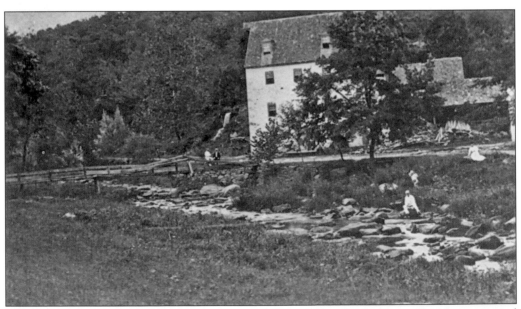

Hartley's Mill was described as a water-powered flour mill and grinding mill, cider press, and ice plant when it was auctioned off in 1923. This photograph from 1910 shows the upper bridge spanning Long Green Run in Glen Arm. The mill might have originated as early as 1760, when the owner at the time, Thomas Lucas, acquired *ad quod damnum* rights on the Long Green Run.

Traveling on Warren Road just before reaching the bridge over the Gunpowder River, one could glimpse the three-story stone gristmill on the left. There is also a house built on the bank above the millrace. The boys' gym, formerly a stable, and the girls' gym/company office had not been built at this point, in 1898. (Photograph by Alice or Lucia Davis.)

The old wooden Bee Tree Mill, which may date back to at least 1849, is shown here in August 1966 on Bee Tree Run at Bentley Springs. The Simpson, Sampson, and Royston families owned the mill. It was burned by criminals in late 2005. (Photograph by John McGrain.)

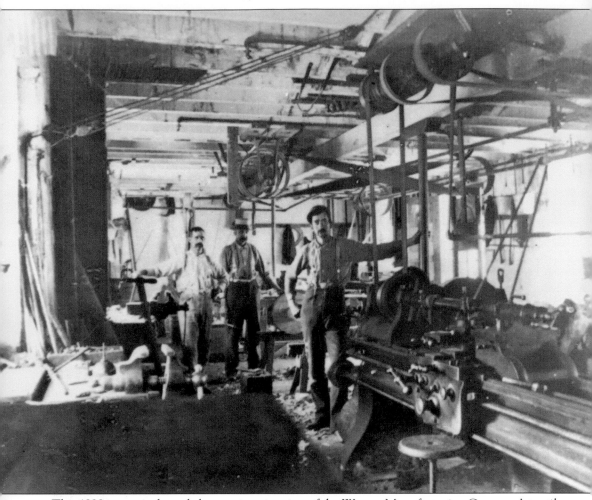

This 1898 image is the only known interior view of the Warren Manufacturing Company's textile mill. Workers or operatives are shown here in the mill's machine shop. The Warren mill located on the Gunpowder River was demolished in 1922. (Photograph by Alice or Lucia Davis.)

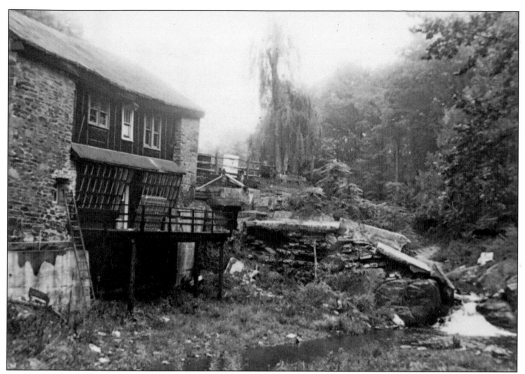

Black Rock Mill, also known as Greys' Rocky Lodge, can be seen at 15213 Falls Road in October 1966. An antique shop operated a business in the structure for a several years in the 1960s. (Photograph by John McGrain.)

A *c.* 1889 image of the Powhatan Mill textile complex shows some snow on the ground and a period gaslight standard in the left foreground. A large dormered two-story building believed to be living quarters is seen at left. The mill was destroyed by fire in 1895 and eventually was taken over by the Woodlawn Cemetery Company, which uses one of the original remaining stone mill buildings as a storage shed.

The Franklintown Grist Mill dates from 1832. The mill was located downstream from the Millrace Tavern, run by baker John Piel until his death in 1882. The town's industrious developer, William B. Freeman, expanded the town's amenities with the Franklin House Hotel, a stone market house, and a spa over a mineral spring. "Franklin Towne" was planned as a retreat for the middle class, but the plan was never fully realized. Franklintown dates from the 1832 plan. The town was on land that was originally part of a land grant known as Morning Choice, patented by John Scutt in 1695.

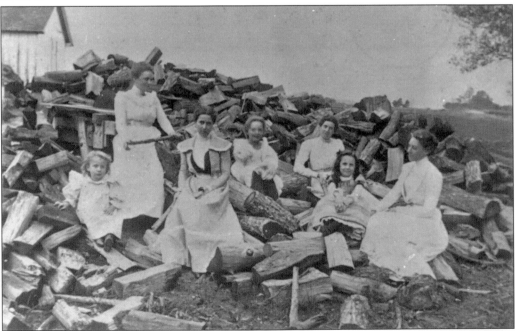

Members of the Davis family of Warren gather with friends around "the famous woodpile" at the Wilson farm in Long Green Valley. The c. 1898 photograph shows the women and girls dressed in summer whites while sitting carefree among the logs in the woodpile.

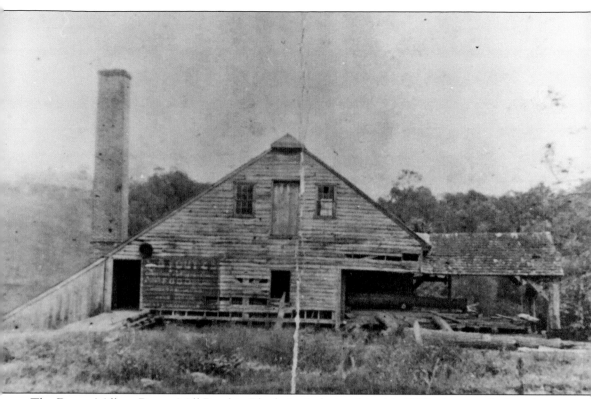

The Dance Mill on Dance Mill Road in Blenheim is depicted in this 1890s photograph. Joseph G. Dance rebuilt the mill in 1841, and by 1880, the census of manufacturers listed the owner as Alexander Dance. That year, the mill was utilizing turbine power with two circular saws to cut 28,000 board feet per year. E. Scott Dance sold the mill to J. W. Isennock in 1919. It closed in 1922 and was mostly razed by 1931. The remnant was being used as a stable in 1988.

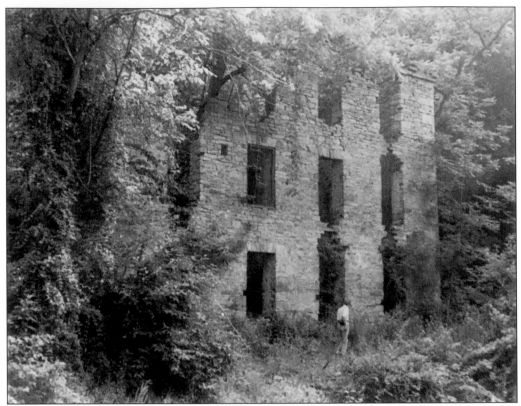

The Ely family built the Mechanics Cotton Mill in 1811 on Ben's Run. The mill had 240 throstle spindles and seven carding machines by the 1820 census. The Ely family then built the Alberton Mill in 1833 in what later became Howard County. The Mechanics Cotton Mill (here in June 1986) was eventually abandoned. (Photograph by William Hollifield.)

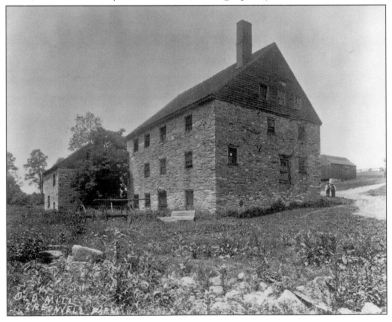

The Ridgely Mill was on the part of the Hampton Mansion estate rented by William S. Treadwell, uncle of C. W. E. Treadwell. The photograph depicts a three-story stone building with a fourth-floor wooden attic. Two men are seen walking on the right. The photograph was taken in May 1921. (Courtesy of the Historical Society of Baltimore County.)

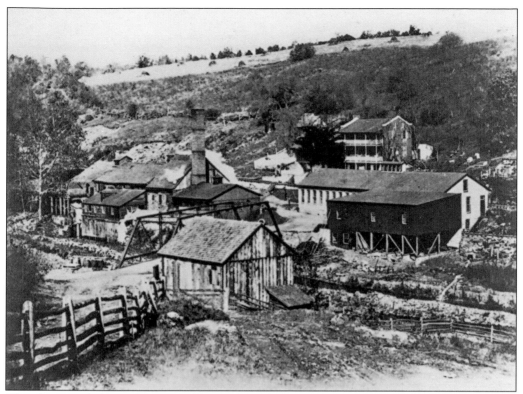

This photograph shows the scope of the Gunpowder Paper Mill in Hoffmanville in 1885 or before. The mill is shown at center with the Hoffman home depicted in the rear middle distance. At the crest of the hill, above the Hoffman home, is a grove containing the Hoffman family cemetery, restored around 1990.

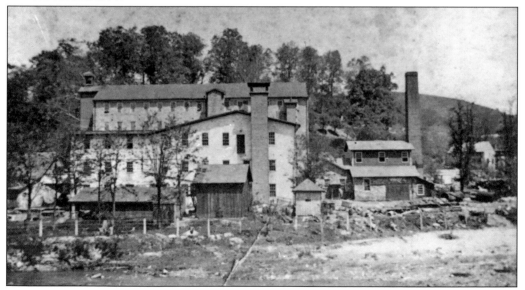

The buildings of the Warren Mill are seen in this c. 1895 photograph from the vantage of the west bank of the Gunpowder River. The five-story main mill structure is seen in the rear along with wood and stone annex buildings; including a blacksmith shop and power plant chimney.

This unidentified stone ruin of a mill, presumably a gristmill, is entitled "Old Mill on the Powhattan Road." A wooden footbridge over the Gwynns Falls, pictured around 1886 in lower right corner, leads to the three-story stone mill. (Photograph by A. H. Brinkmann.)

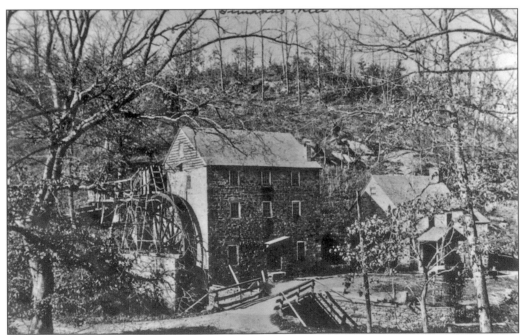

Mitchell Mill or Summerfield Mill on Cub Hill Road is seen here in an 1870s image. The large stone structure was James Carroll's fulling mill around 1824, shown as Carroll's Wool Factory on Robert Taylor's 1857 *Map of Baltimore County*. August Oals converted it to a gristmill in 1874. He leased it under the name of Summerfield Mills to Charles Oals. Oals lost it to fire in 1879. Stephen D. Mitchell purchased the ruin in 1893, converting it to a roller mill. Mitchell's heirs sold it to Joseph D. Fulker, who lost it to fire on December 26, 1903.

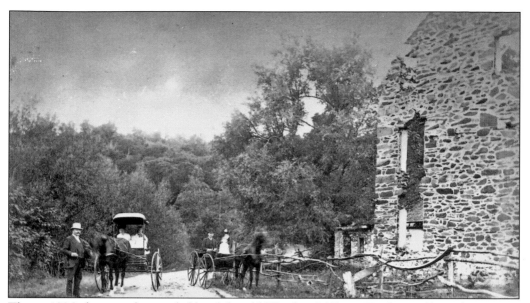

This *c.* 1886 photograph is probably of the old Windsor Mill on Windsor Mill Road in a state of ruin. The folks appear to be enjoying a day's outing traveling in their one-horse buggies. The fence surrounding the old stone mill is constructed partially of tree branches. (Photograph by A. H. Brinkmann.)

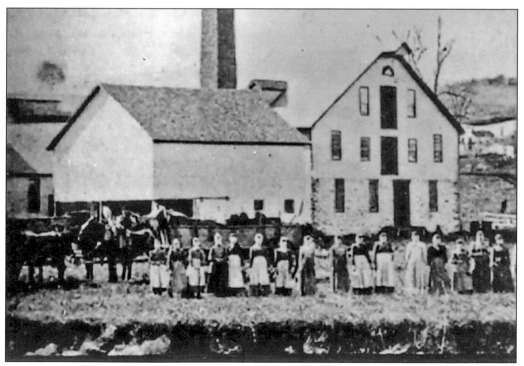

Workers, mostly women in long dresses, pose in front of Beckley's Paper Mill in Beckleysville in the 1880s. The mill, established by Jacob Beckley, was a thriving industry that contributed to increasing the population in the surrounding area. (Photograph from a 1930s *Federation PTA News* magazine.)

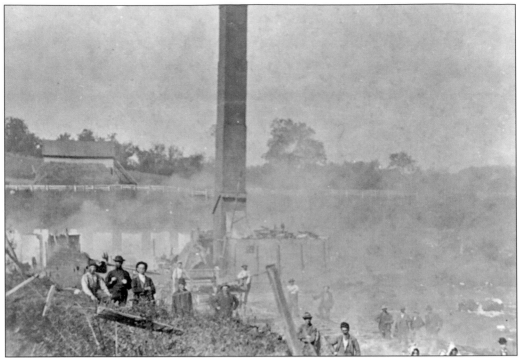

Beckley's Paper Mill in Beckleysville is shown here in the aftermath of the fire on October 12, 1902. The photograph shows smoking ruins, but surprisingly, the mill's main chimney remains standing. The barns and outbuildings can be seen in the background.

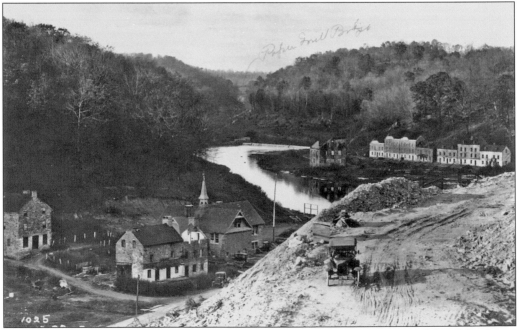

This November 15, 1922, aerial view of the Warren Mill shows the Paper Mill Road Bridge in the top distant center, barely visible between the trees. A new bridge was built in 1923 to replace the old wooden covered bridge. (Courtesy of the Peale Museum.)

Seven

HUSTLE BUSTLE

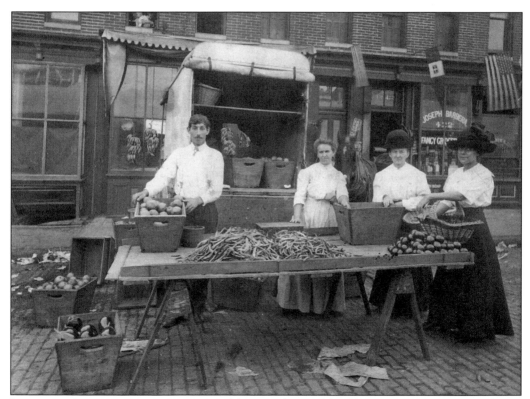

Immigrant farmers in Germantown raised fruits and vegetables, like carrots, celery, onions, beets, and parsley—otherwise known as stoop crops because farmers had to crawl on the ground to weed and harvest them. After cleaning and bunching their produce, the farmers traveled to the Bel Air Market to sell them. A typical Germantown farm family rented a stall or sold their produce from the back of their wagon.

Scott's Tan Yard, located on Tanyard Road, north of Western Run Road, is pictured here in the early 20th century. The photograph shows one of the three original stone tannery buildings on the left. Abraham Scott Jr. constructed the buildings around 1838. (Photograph from a *Federation PTA News* magazine.)

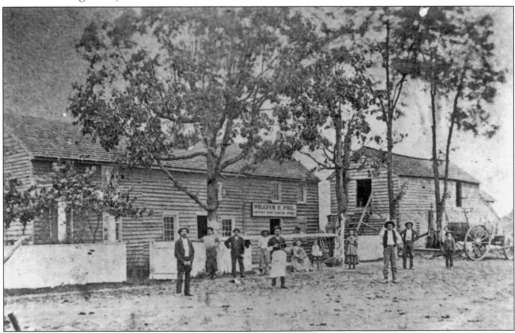

Unfortunately, the author cannot identify any of the individuals in this early-1870s photograph. It is known, however, that John H. Piel, the baker from Franklintown, took over the original Hebbville Store from his brother-in-law, Columbus Dettmer, in 1869. Take note of the infant seated on a stool in the center right.

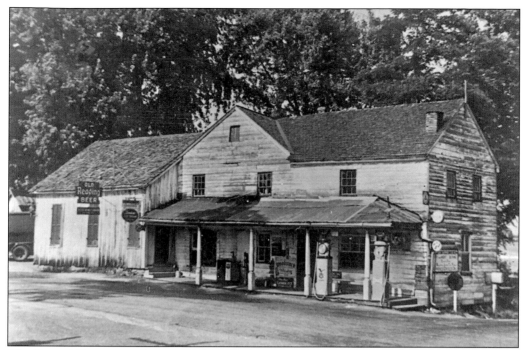

John Brown's Store sits at the corner of Falls and Shawan Roads. This picture taken in the early 1920s shows the old frame building with two gas pumps and an "Old Reading Beer" sign. John Brown's Store remains there today but is housed in a picturesque stone cottage. It still sells beer.

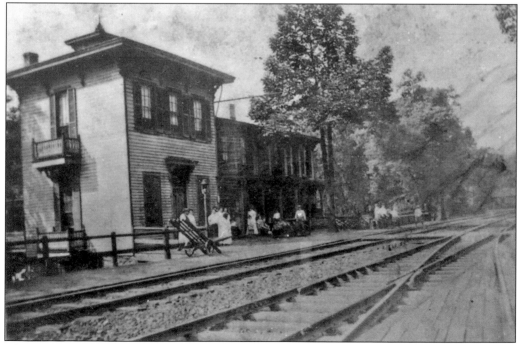

This early-20th-century Americana scene is captured in an image at Bentley Springs, a luxury resort once located in northern Baltimore County. The picture shows the rural store, the U.S. Post Office, and the tracks of the Northern Central Railway.

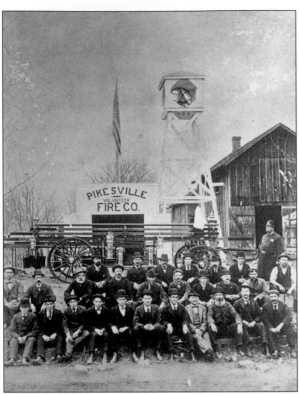

The station crew of the first Pikesville Volunteer Fire Company gathers for a *c.* 1897 group photograph. The firehouse was located at Reisterstown Road and Sudbrook Lane. A Holloway ladder truck with chemical extinguisher is displayed behind the firemen.

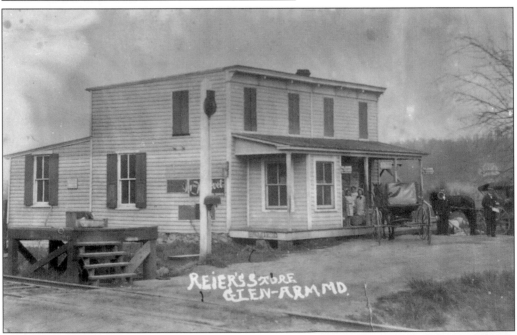

A postcard with an August 1915 postmark shows horses and buggies parked in front of Reier's Store in Glen Arm by the railroad tracks. The scene takes place sometime before 1915. It is likely the store was owned by H. S. Reier, who was listed as a butcher in Glen Arm in the 1915 Farmer's Directory of Towson.

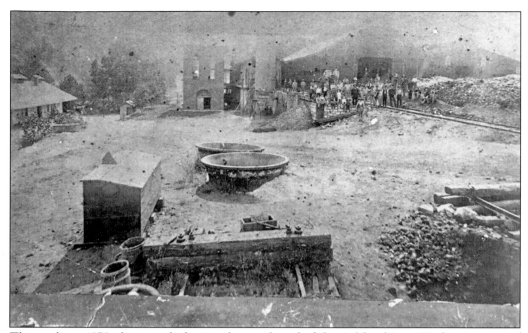

This early, *c.* 1870 photograph depicts the north end of the Ashland Iron Works. A group of workers is standing outside of the entrance. The Ashland Iron Works was co-owned by Philip Albright Small (1791–1875) of York, Pennsylvania, and his brother, Samuel Small. Col. Walter Symonds Franklin (1836–1911), a Civil War Union army veteran and son-in-law of Philip Albright Small, was the manager of the Ashland Iron Works.

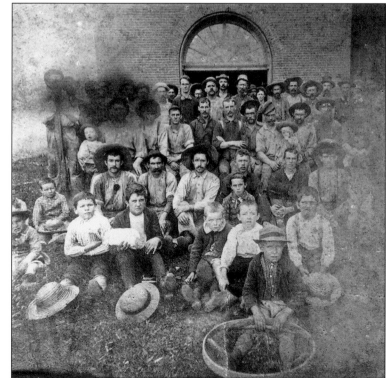

Some of the workers of the Ashland Iron Works are shown here posing with their children at the outside entrance of the works around 1870. The Ashland Iron Works was instrumental in producing plows, harrows, cultivators, shovel plows, corn drags, and the Woolsey harrow. It was also a target of Confederate raiders who were sponsored by a family of local sympathizers. The Confederate raiders spared the ironworkers.

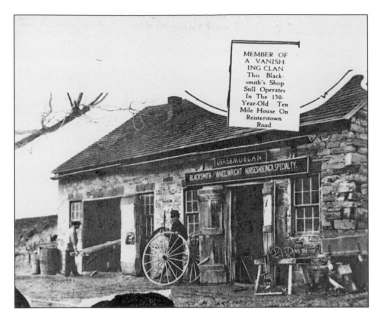

The sign advertises Charles B. Morgan's skills as a blacksmith, wheelwright, and specialist in horseshoeing. The 1930s image shows a man wearing a bowler and holding a wagon wheel. Another worker is shown at the left. The shop operated in the 150-year-old Ten Mile House located on Reisterstown Road. (Image from a *Sun* rotogravure; courtesy of the Historical Society of Baltimore County.)

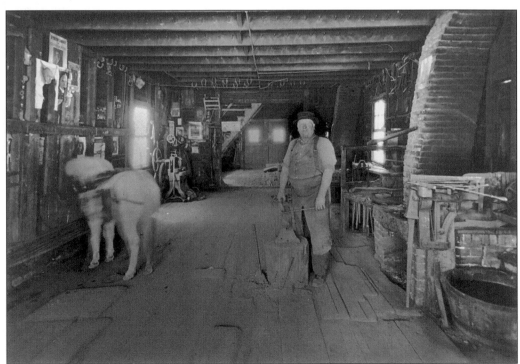

William Smith Hoffman, shown between 1908 and 1912, stops working on a horseshoe at his anvil and poses for the camera in his blacksmith shop at 913 Frederick Road in Catonsville. The tethered horse waits patiently nearby. The building was remodeled for a beauty shop in the 1930s and later torn down and used for a parking lot by Salem Lutheran Church.

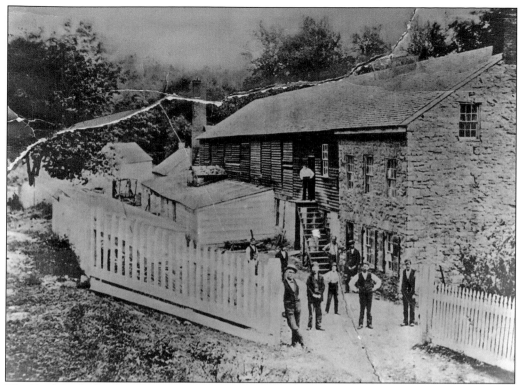

The Rockland Bleach and Dye Works are shown here before the fire of February 1884. A group of 10 unidentified men wearing shirtsleeves stands outside of the part-stone and part-clapboard bleachery. The plant was owned and managed by English-born bleacher Robert Wright in 1832. It was rebuilt after fire in February 1884. Another fire on May 4, 1982, caused the business to close.

The John S. Wilson Company lumberyard, located at 741 Frederick Road in Catonsville, was founded in 1881. It was known as Wilson and Poehlmann at that time. In August 1974, the building survived a major fire. This 1885 photograph depicts the building with its signage advertising hardware, paints, and oils.

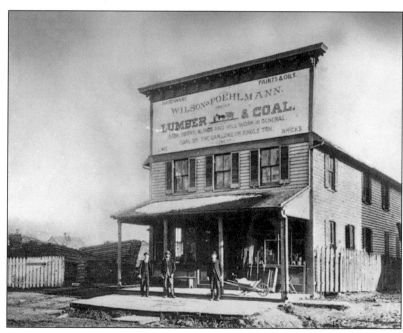

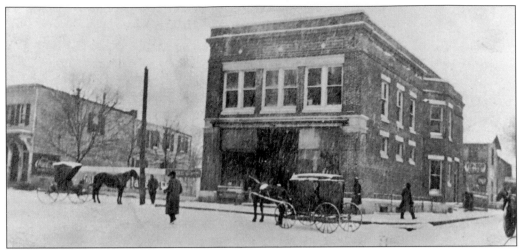

The hustle bustle of the Pikesville store known as Corbett's General Store is shown in this c. 1910 photograph. The snowy scene depicts the two-story building located at Reisterstown and Walker Avenues. The building was the only one in Pikesville with an elevator at that time. Robert Corbett inherited the business started by his father, Timothy Corbett, who had been a Southern sympathizer. Timothy Corbett spent time in Fort McHenry but was released and allowed to return home after contracting pneumonia. The store remained in business until World War II.

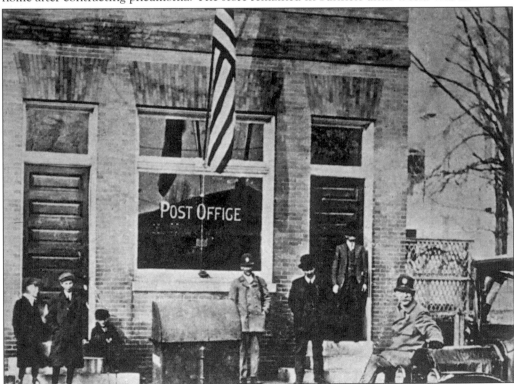

Robert Parlett, the superintendent of the post office, stands in the doorway of the first Towson Post Office (1896–1927) in 1915. William Nichols, the man wearing a dark suit standing on Parlett's right, is the postal clerk. The men wearing gray uniforms and hats are postal workers. (Photograph by a *Sun* photographer.)

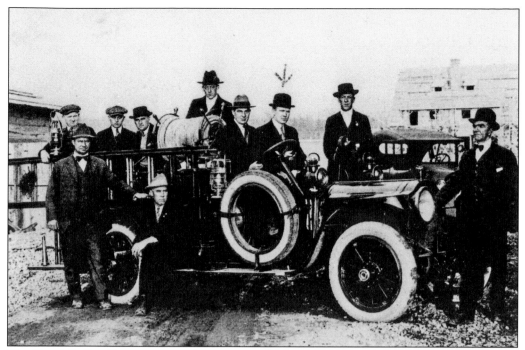

The Dundalk Fire Department strikes a pose with Capt. John Patrick Ward in the center, third from the right. The photograph was taken on September 10, 1918, and features a 1913 Packard fire truck. (Courtesy of the Historical Society of Baltimore County.)

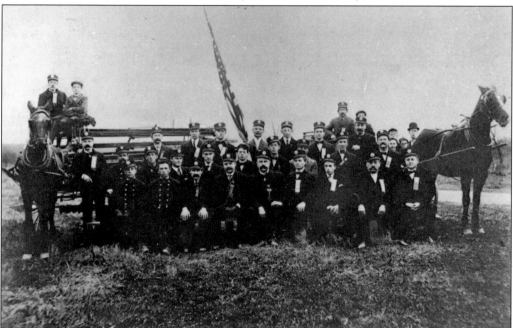

The entire roster of the Lansdowne Volunteer Fire Association poses with its two horse-drawn pieces of equipment around 1902. The fire department was organized in 1902 after a fire destroyed the home of Mr. and Mrs. Foger on Fourth Avenue. The frame firehouse was built on land donated by Charles W. and Mary Hull.

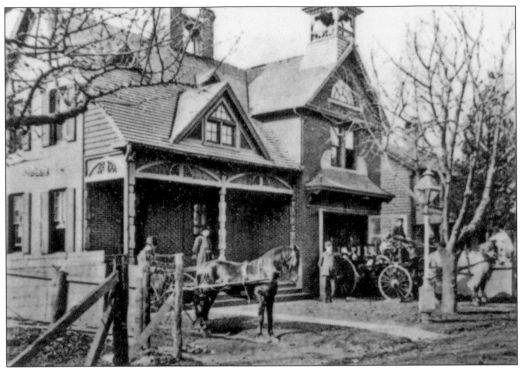

The original Catonsville Fire House at 26 Bloomsbury Avenue was designed by William Young and built between 1887 and 1891. This *c.* 1891 photograph shows a crew with a horse-drawn Holloway chemical engine. Chemical fire engines cost about $450. Soda and acid mixed in the pressure mechanism formed pressurized gas used to force water from the tank out through a hose.

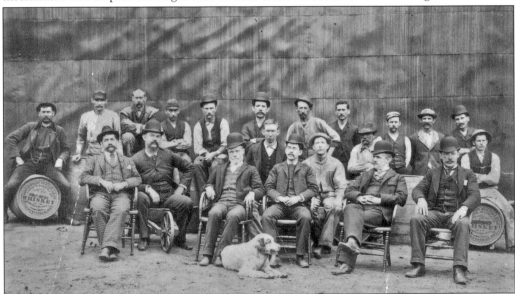

Employees of John Wight's Sherwood Distillery in Cockeysville come together for this group photograph in the late 19th century. Most of the 21 men are wearing bowler hats or caps while sitting or straddling whiskey kegs. Their faithful dog lies front and center. The kegs read, "Sherwood Distillery Copper Distilled Corn Mash Whiskey."

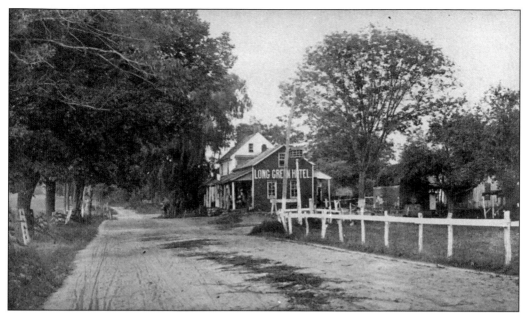

This *c.* 1895 photograph depicts the Long Green Hotel's welcome sign beckoning visitors up ahead on an unpaved dirt road in Long Green. Guests of the hotel would surely enjoy the surrounding rolling country vistas characteristic of Long Green Valley. Today Long Green Valley comprises over 6,000 rural agricultural acres of pastoral panoramas.

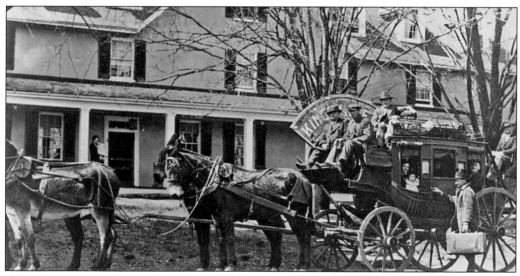

A four-horse stagecoach is parked in front of the Kingsville Inn at 11750 Bel Air Road in Kingsville, possibly around 1924. Around 1950, the inn was called "Charlie Murray's Kingsville Inn." Henry Ford purchased the stagecoach and displayed it in the Henry Ford Museum at Dearborn, Michigan. The inn later became the E. F. Lassahn Funeral Home.

Henry Hess managed the Sherwood House on York Road in Cockeysville at the time of this photograph in 1898 or 1899. The workers at the nearby Beaver Dam marble quarry stayed there. Henry Hess owned a general store, cows, horses, pigs, and a greenhouse where he grew vegetables and strawberries. The building stood on the west side of York Road north of Hillside Avenue. In the photograph are, from left to right, Elizabeth (Leister) Hess (1841–1919, wife); Henry Hess Zink (1896–1962, grandson); Anne Catherine (Hess) Zink (1864–1949, daughter); Henry Hess (1842–1915); A. Leister Zink (1894–1988, granddaughter, a sometime teacher before 1922 in the school at Warren); John J. Zink (1861–191, son-in-law); George Strouse; Charlie Hewson (on the porch at right); and Joe Schroeder, a stable hand holding a horse.

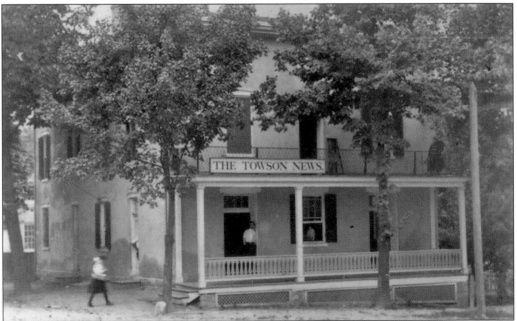

Shown in this *c.* 1906 photograph are the offices of the *Towson News*, published between June 17, 1905, and August 28, 1909. The newspaper merged with the *Union* to become the *Union News*. The building was a large two-story plaster over brick or stone structure with a roof having a slight incline. Note the dog on the left side scratching his back on a tree.

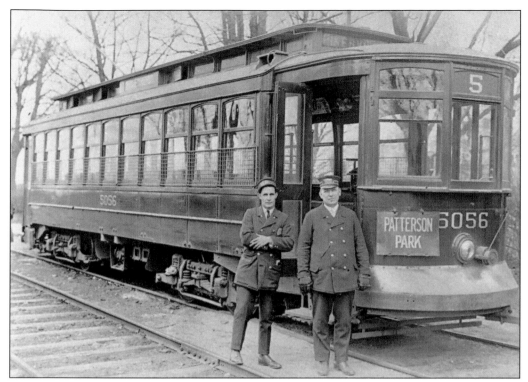

Conductor Charles Howard Clifton and motorman Edward Walford stand beside Car 6056. The Baltimore, Pimlico, and Pikesville line of the Baltimore Traction Company started streetcar service on July 25, 1892. Car 6056 made its last run from Patterson Park to Pikesville in 1921.

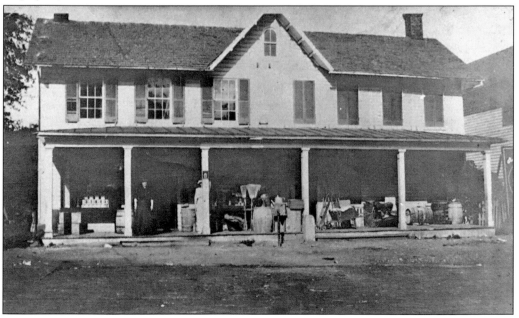

Foley's Store was located on Reisterstown Road in Pikesville. It is shown here as it appeared in 1890. By 1910, the store had gas pumps. William Foley, an immigrant from Ireland, started Foley's Store around 1857. His young assistant was John McGuire.

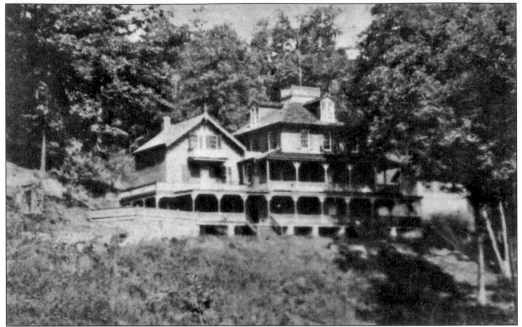

The three-and-a-half-story Bentley Springs Hotel sits on the slope behind the Bentley Springs Station. The hotel accommodated boarders seeking an escape from the city during the hot summer months. It was also conveniently accessible by railroad from the city. Charles William Bentley was the proprietor at the time of this early-20th-century photograph.

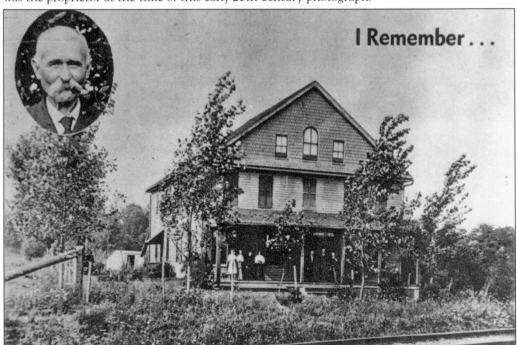

I Remember . . .

William Louis Smith built the Middle River Hotel (pictured in the 1880s) in 1882. Farmers, fishermen, and participants in traveling magic lantern shows were patrons. Middle River, at the time, consisted largely of farms and swamps. (Photograph by a *Sun* photographer.)

90

The Western Run Toll House and wheelwright shop located at 947 Western Run Road (shown in 1976) was built between 1800 and 1850 in response to an increase in transportation. It is shown on an 1859 map for Baltimore County. In 1896, Melchior A. Tracey was toll keeper. The tollgate remained until 1918. (Photograph by G. W. Fielding.)

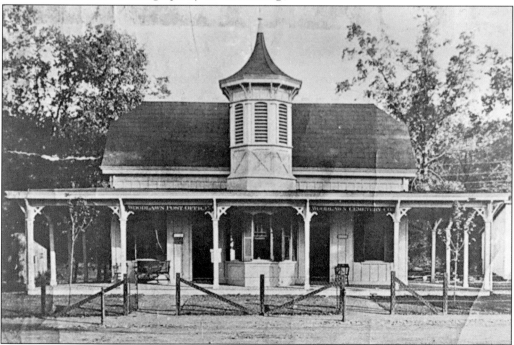

The Woodlawn U.S. Post Office was housed in a structure that also doubled as a trolley station waiting room. Woodlawn Post Office was previously located across the Gwynns Falls in Powhattan. Special railway postal trolley cars moved mail from station to station. This photograph was taken after 1905.

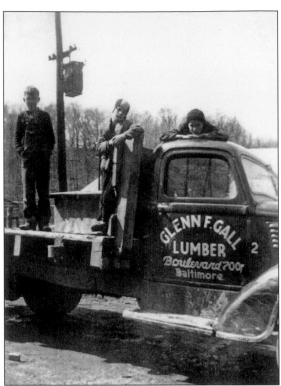

Young boys pose on top of the Glenn F. Gall Lumber Truck. The company was located on Belair Road near or south of Gunpowder Falls.

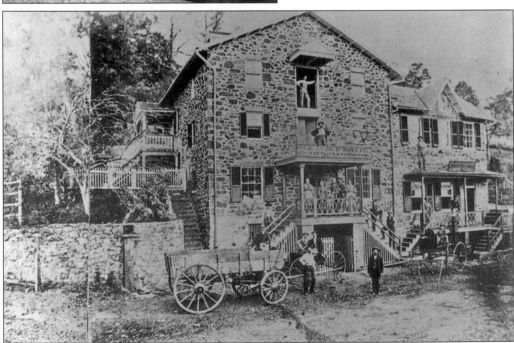

The Franklintown Store sign hanging over the front porch reads, "Franklin Store By John H. Piel: Grocery, Flour, Feed of all kinds." The photograph dates back to the 1870s. The owner, Piel, had purchased the Franklintown Mill in 1869, which he ran in conjunction with his baking business until he died from smallpox in 1882.

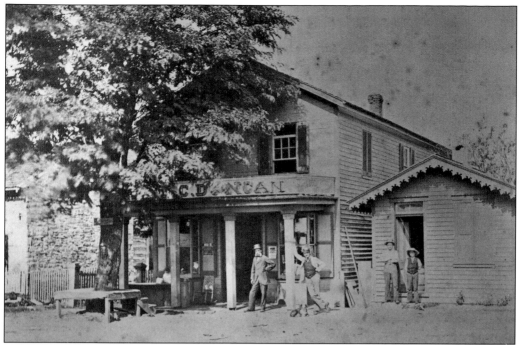

The John D. C. Duncan Store was located in Cockeysville, north of Shawan Road on the east side and south of Broadmead, the Quaker-sponsored life-care community. John D. C. Duncan is standing on the left with hand on his hip while his son, George C. Duncan, is leaning against a post. The second floor of the old frame building was used for lectures, suppers, and other events. The photograph dates to around 1889. (Courtesy of the Baltimore County Historical Society.)

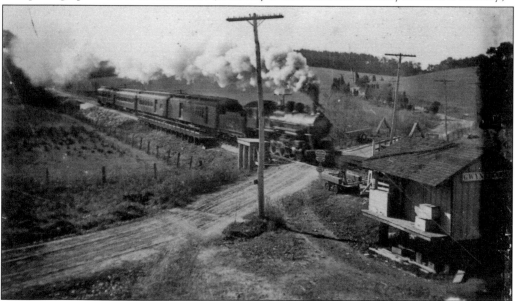

A steam locomotive roars through the Gwynnbrook Station above Owings Mills. The train was part of the Western Maryland Railway, used predominantly for hauling coal and freight. The rails went from Baltimore out to Union Bridge, whereupon western expansion was delayed because of the Civil War. (Courtesy of the Baltimore County Historical Society.)

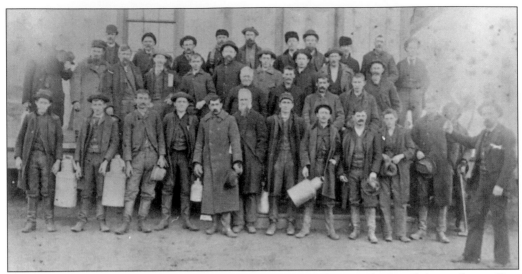

Milk shippers pose at the White Hall station in this *c.* 1900 photograph. From left to right are (first row) John Nicholas Norris (father of Catherine Norris Ensor), Will Norris, Nelson Richardson, Egbert Norris, Richard Wiley (father of Howard Wiley), Ben Garrett, Charlie Wagner (father of Charley Wagner), unidentified, Robert Bacon, Howard Burns (brother of Mattie Burns Messer), John Thomas Ayres, ? Ayres (an African American), and Thomas Curry (station agent); (second row) John Pullen[?] (grandfather of Bob and Wendell Pullen[?]), John T. Moore (father of Evelyn Moore Best), John T. Amos, and Haser Roser (father of Linwood Roser); (third row) unidentified, Henry Fowble, unidentified, Harry Almony, Nicholas Lyle, Thomas Parrish, Leonard Slade, Oscar Almony, Lum Slade, and unidentified; (fourth row) unidentified, ? Kroh, Ray Slade (brother of Lemuel Slade and Lum Slade), March McComas, Harry Burns, Tom Hunter, John Burns (father of Will Burns), unidentified, Thomas Elliott, and Lilburn Nelson.

A crowd of children gathers in front of the Warren Company Store on Main Street in Warren sometime before World War I. The stone store building has a clapboard addition on the side. A bread truck advertising breads and pies is parked behind the children. (Courtesy of the Bunker Hill Foundation.)

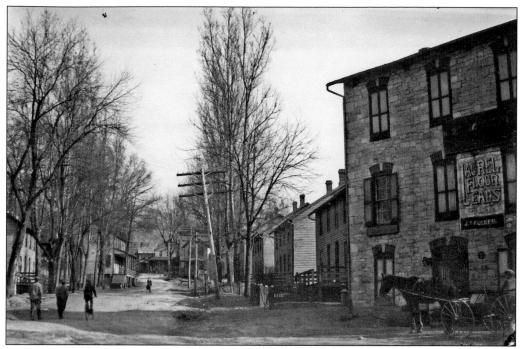

The sign on the stone building on the right at Fulker's Store in Phoenix in 1921 advertises "Laurel Flour Leads." About 1923, the stone from the building was recycled into a small shopping center at the corner of York and Regester Avenues, the site of Purdum's Pharmacy. (Photograph by William C. Kenney.)

Leisenring's Store on Front Street was built around 1885. George W. Leisenring was the son-in-law of Dr. John Gottlieb Morris (1803–1895), the founder of Lutherville. Men and boys pose on the porch in this *c.* 1890 photograph. The building has since been converted to a private home.

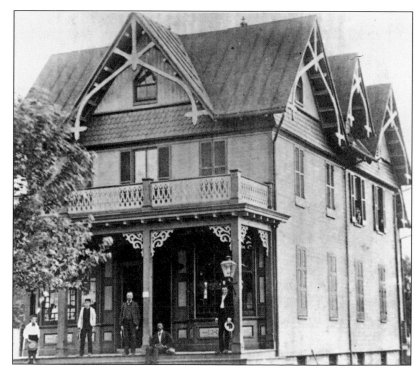

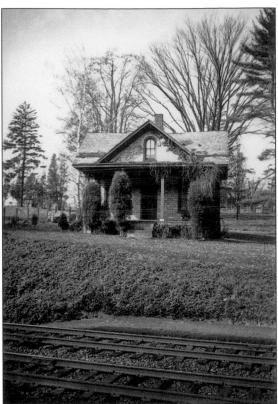

Just beyond the railway tracks seen in the foreground lies the Northern Central Railway stationmaster's home. It was a two-story single-gable brick house located at the Ashland Iron Works. The photograph was taken between 1920 and 1930. The Northern Central Railway connected Baltimore with Sunbury, Pennsylvania.

Baltimore County historian John McGrain identified this old house as probably being Daniel Brooks's Belfast Store. The photograph dates to about 1900. The Belfast Store stood on the grounds at 820 Belfast Road. The house is perched on the edge of a dirt country road, a challenge to navigate in inclement weather.

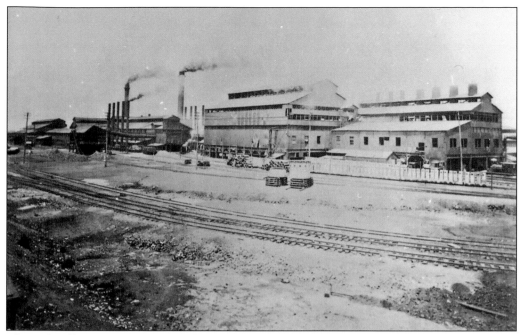

The rail mill at Sparrows Point is shown in this photograph taken on May 24, 1902. The Point was named for Thomas Sparrow, the recipient of a land grant from Lord Baltimore in 1652. In 1887, construction of the works known as Maryland Steel began. It opened in 1890 and evolved into the largest steel mill in the world.

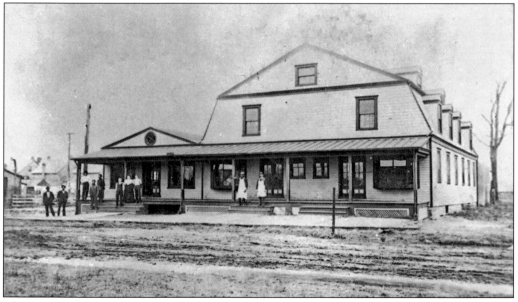

The Maryland Steel Company's Northside Store was located at Ninth and I Streets. The building in this 1910 photograph was razed about 1945. All of Maryland Steel Company's stores operated without a profit. Credit was available to workers by means of redeemable coupons issued for goods. The workers' debts would be satisfied by a deduction from their paycheck. In 1916, Bethlehem Shipbuilding Corporation acquired Maryland Steel and renamed it Bethlehem Sparrows Point Shipyard.

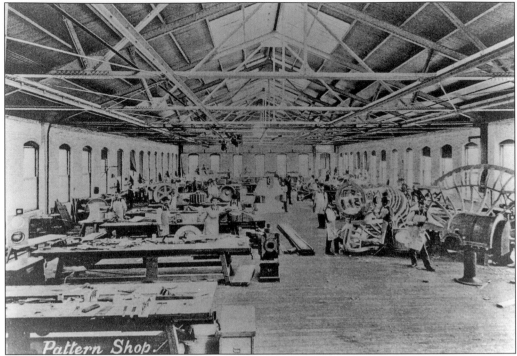

This remarkable interior view of the Maryland Steel Company's Sparrows Point plant depicts workers in the company's pattern shop in 1895. The company provided housing for its employees to guarantee a steady workforce in the relatively remote area. Maryland Steel built cargo ships, tugboats, and coastal passenger ships.

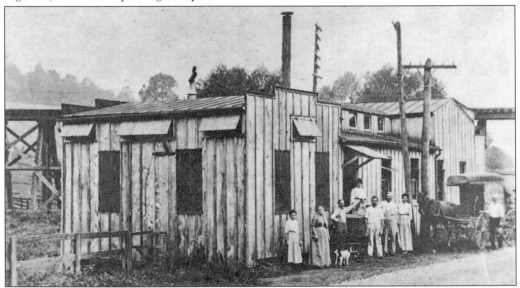

John Mumma's Laundry in Long Green did a thriving business from 1900 until about 1920. The photograph shows male and female employees along with a dog and horse and wagon. The board-and-batten building stood across from the old Maryland and Pennsylvania Railroad depot in Long Green at the point where the railroad crosses Long Green Road on a trestle. The laundry was reportedly built of sycamore trees taken from James Brogden's farm. (Photograph by a *Sun* photographer.)

Eight

PLEASURABLE PURSUITS

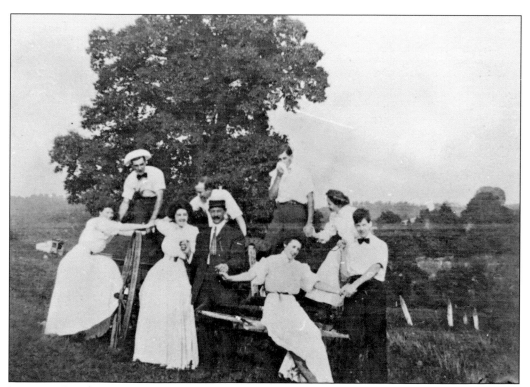

Marjorie Brooks McKee, Heath Tarbert, Helen Tarbert Linville, Emory Michael, and three unidentified people candidly pose around and on a four-wheeled conveyance, minus the horse, in the Sparks countryside. Those named individuals are not specifically located in the c. 1916 image.

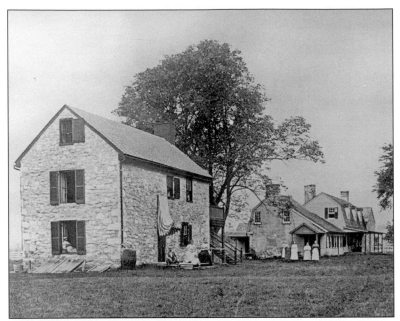

The former stone slave quarters of Jenkins Purchase, the R. Hillen Jenkins 18th-century estate in Hydes of Long Green Valley, is depicted in this late-19th-century image. The building later served as housing for freed slaves. On the right are women and children of the Jenkins family standing next to their home, Ingleside. The house was torn down in 1906 because of a termite infestation.

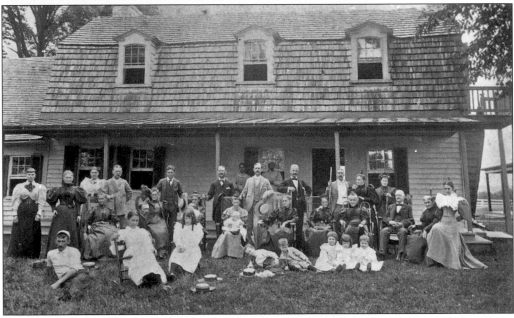

The July 5, 1895, setting for the Jenkins family reunion was Ingleside, their estate in Hydes. Those identified are (first row) Willie Nagle (farm manager); Lydia Fleury, Corinne Fleury, Raymond Jenkins, Armour Jenkins, Lydia Jenkins, Virginia Fleury, and Mary Armour Jenkins; (second row) two unidentified servants, Mrs. William Saxton (Aunt Jo), Paul Aime Fleury II, Mrs. Paul A. Fleury, Mrs. Jacob White, Adele Fleury, Mrs. Armour Jenkins with Mark, Annie Jenkins, Mrs. George Jenkins, Mrs. Brook Pleasants, Brook Pleasants, unidentified, and Ella McGuire; (third row) unidentified servant, William Saxton, Augustine Fleury, Jacob White, William Armour Jenkins, Hillen Jenkins, Talbot Jenkins, Mrs. Talbot Jenkins, and unidentified. On the porch are two unidentified servants. The occasion was described in the newspaper as "an old fashioned country dance."

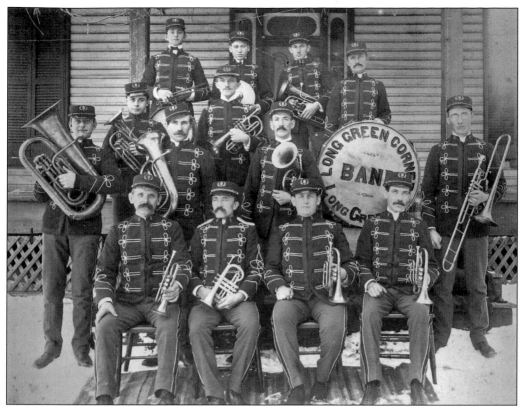

The Long Green Valley Cornet Band sits in full regalia with brass instruments at the ready on the steps of the former Herbert J. Lee home around 1904. The cornet is similar to the trumpet except its tone quality is more mellow and it is more compact in shape. (Photograph by Sar View Photograph Company.)

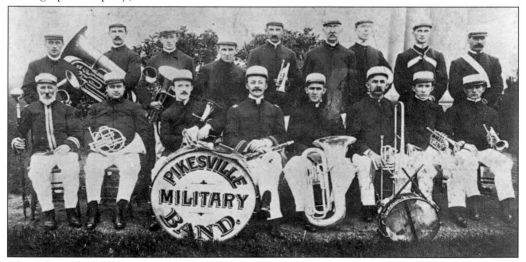

The Pikesville Military Band is shown here in 1915. The band was originally known as the Citizen's Cornet Band. They practiced at the International Order of Odd Fellows (IOOF) Hall in Pikesville and played at the funerals of IOOF members. After World War I, the band dissolved and the instruments were sold.

Elizabeth Howard Hayes (1817–1902) and John Spence Hayes (1815 or 1816–1898) compose a pretty picture while sitting at the open rear door of the Stemmer house in the Essex area. An elegant hedge of mature boxwoods graces the setting. The photograph was taken in the early 1890s.

Another 19th-century view of the rear doorway of the Stemmer house shows wisteria vines framing the open doorway with those posed identified as, from left to right, Tom Harrison (freed slave), Elizabeth Howard Hayes, Sallie Hayes, Robert B. Chapman I, and Belinda Hayes Chapman. The Essex home was later moved in the 1930s to Caves Road.

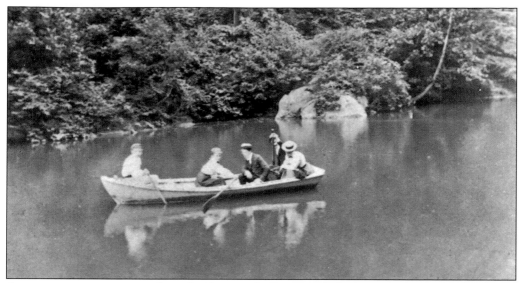

A group enjoys a canoe trip along the Gunpowder River in 1895. The river was a source of cooling recreation for those looking for a reprieve from the summer heat. The Gunpowder flows through farmlands and forests of Baltimore County. (Photograph by Alice or Lucia Davis.)

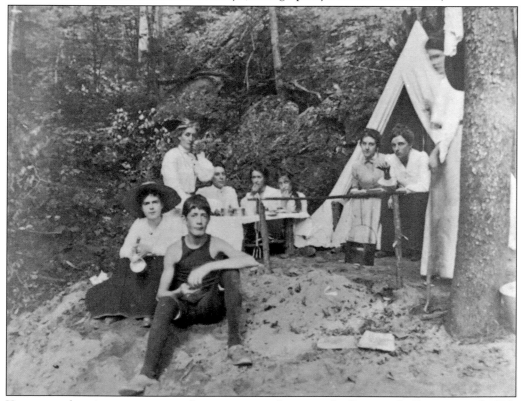

Young people enjoy a camping and canoeing expedition on the Gunpowder River around 1898. Those outside of the tent are identified but not specifically located: Lucia Davis, Mrs. Chandler, Douglas Chandler, Olive Rogers, Barbara Chandler, Alice Chandler, Ida Schumacher, Alice Davis, and Cara ?.

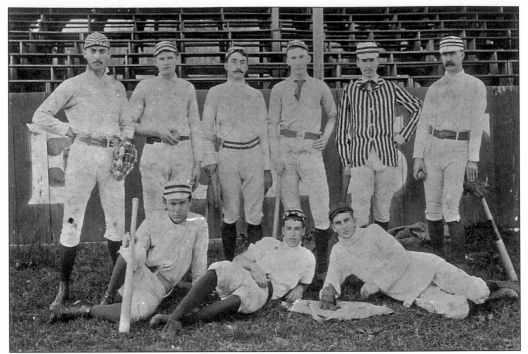

The Towson Baseball Club celebrated defeating Catonsville by a score of 10-1 and posed for this official photograph. The game was held at the old Oriole Park. Towson was triumphant in the 1890 season, but by 1893, the team was almost defunct. They are, from left to right, (seated) Z. Howard Isaac; Douglas B. Turnbull, shortstop; and Edward Guest Gibson, outfielder and substitute pitcher; (standing) Randolph M. Isaac, first base and catcher; Otis Stocksdale, pitcher; John S. Ensor, shortstop and catcher; W. George Manley, outfielder; R. Grason George, third base; and Charles S. Grason, first base.

A 1911 photograph of the White Hall baseball team includes the following players: John T. Moore (with bat), Fred Kroh, Will B. Burns, Clarence Burns, Charles B. Burns, Ed Burke, and John Ensor. By 1916, teams from Corbett, Phoenix, and White Hall competed in a league. Halliday Brothers, nurserymen, provided a local ball field.

John Morris Reese holds the bike steady for sister Eleanor Reese, later Eleanor Reese Needham, near the front steps of the Reese family home on the corner of Franke and Morris Avenues in Lutherville. The bicycle is shown decorated in celebration for the Fourth of July. The photograph dates to around 1899.

A very young John Morris Reese (1896–1979) exhibits his skill in handling a croquet mallet that is almost as tall as he is in 1897 or 1898. Young John is playing on the grounds of Oak Grove in Lutherville. (Photograph by Emma K. Woods.)

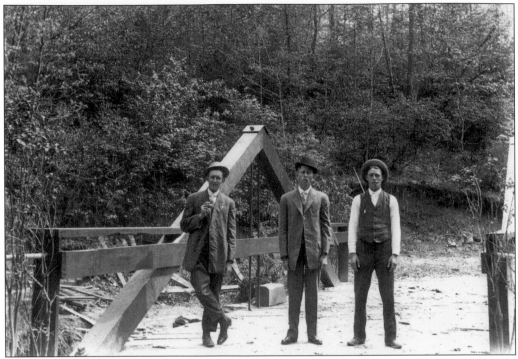

Milton Merkel, Al Walters, and P. Martinon pose on the Ashland Avenue Bridge on May 17, 1908. (Courtesy of the Historical Society of Baltimore County.)

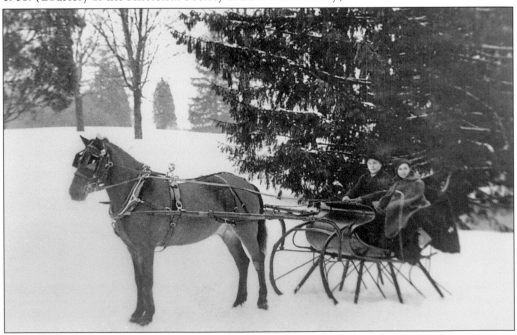

Samuel Moor Shoemaker III and his sister enjoy a ride in their one-horse open sleigh on the snowy grounds of Burnside Farm in Green Spring Valley in the winter of 1903 or 1904. The large dairy farm was renowned for its valuable herd of Jersey cattle. Samuel Shoemaker III became a respected Episcopalian priest who spent time in China as a missionary.

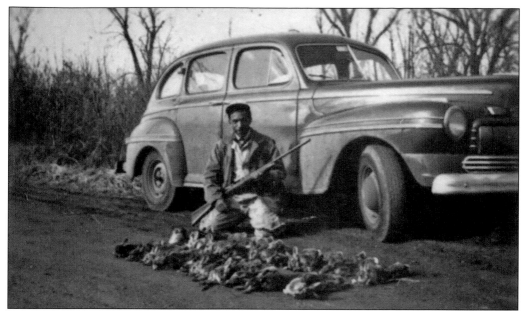

Hilton Diggs cradles his rifle and displays his trophies from a recent rabbit hunt. Hilton lived in the Piney Grove community of Boring. Many families supplemented their diet with meat from rabbits, foxes, squirrels, and quail. At one point, rabbits almost became extinct, so Baltimore County commissioners passed a law against shooting rabbits for profit

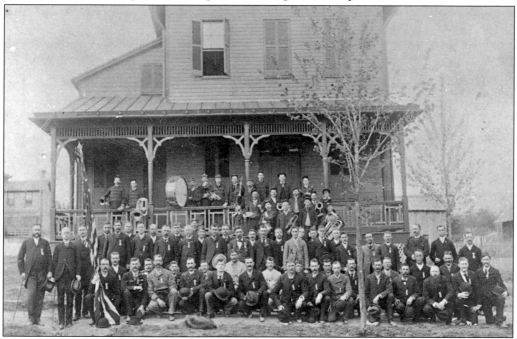

C. Lyon Rogers of Owings Mills organized the Centennial Grange No. 161 of the Maryland State Grange in Towson in 1876. The building shown in this 1892 photograph opened in 1890, received its deed in 1891, and was dedicated in 1892. The Grange folded in 1902, and the building was demolished in 1912 to make way for a garage. The law offices of Venable LLP at 210 Allegheny Avenue in Towson occupy part of the original site. (Photograph by David F. Painter.)

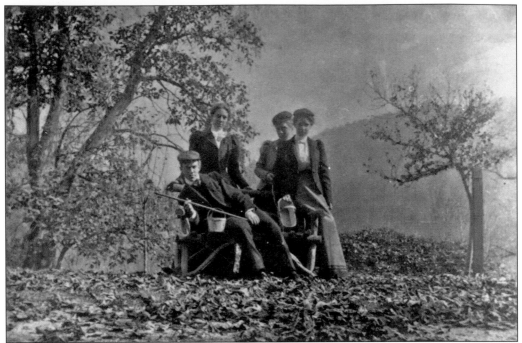

David Davis, Olive Rogers, Alice Davis, and Helen W. Torfe (order unknown) are shown collecting nuts in the Loch Raven area or near the Gunpowder Falls River near Warren in 1898. The group pauses for a rest while capturing the moment on film. (Photograph by Lucia Davis.)

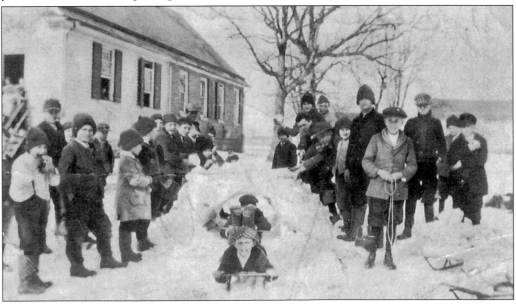

Students at the Perry Hall Elementary School enjoy a blustery day in the snow sledding down an embankment. The undated photograph probably takes place at the second Perry Hall School, originally a three-room brick school, located at the intersections of Forge and Belair Roads. This structure was built on land donated by Harry Dorsey Gough Carroll, a resident of Perry Hall Mansion, after the first Perry Hall School, a small log cabin built in 1874, burned down. (Courtesy of the Historical Society of Baltimore County.)

Nine

NO PLACE LIKE HOME

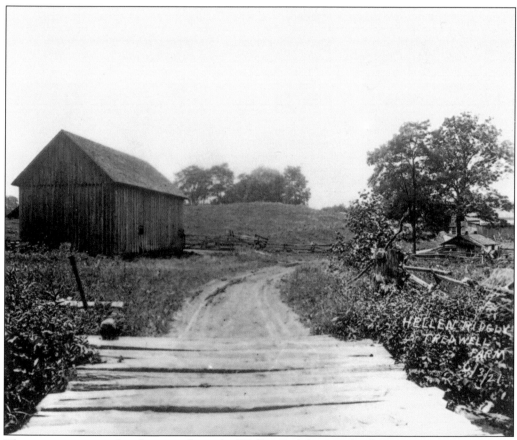

The inscription on the photograph reads, "Hellen Ridgly; Treadwell Farm; June 3, 1921." The farm was leased to William S. Treadwell (1840–1930). It was located on the Hampton Estate in Dulaney Valley. A wooden bridge over a culvert is seen in the foreground. The farm was later condemned for the Loch Raven Reservoir expansion project. (Courtesy of the Historical Society of Baltimore County.)

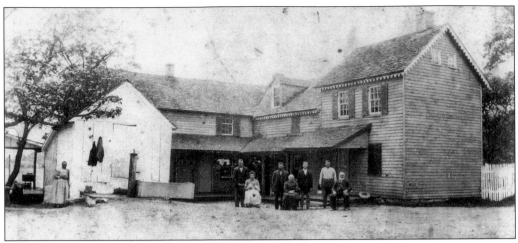

The John Dietz homestead consisted of a frame Queen Anne–style home with a gable roof, wraparound porch, and various outbuildings that comprised the family farm and nursery. The Dietz family acquired the property, located at 9641 Belair Road in Perry Hall, in 1912. At that time, the homestead was in an area known as Germantown, which extended along Belair Road from Forge Road to the Halbert House, a structure that houses the Perry Hall Library today. In the 20th century, Germantown and the surrounding areas were collectively known as Perry Hall. (Courtesy of the Historical Society of Baltimore County.)

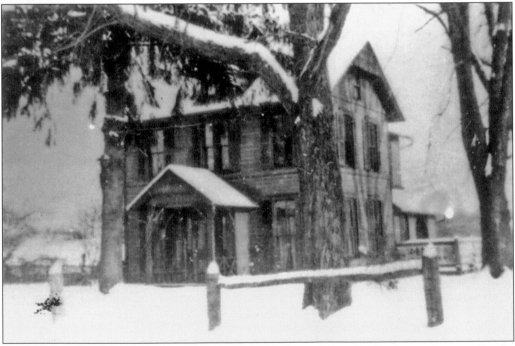

The first paper maker in Maryland was William Hoffman (1740–1811), who made paper for the Continental Congress. His grandson, William Henkle Hoffman (1810–1886), built this, his third home, on Gunpowder Road. His previous homes were located at Clipper Mill and Gunpowder Mill. The mansion, seen here, was located at the paper mill town of Paper Mills, later renamed Hoffmanville by the U.S. Postal Service in the 1880s. The mansion lasted from 1867 until about 1943. Local children enjoyed playing in its spooky vastness.

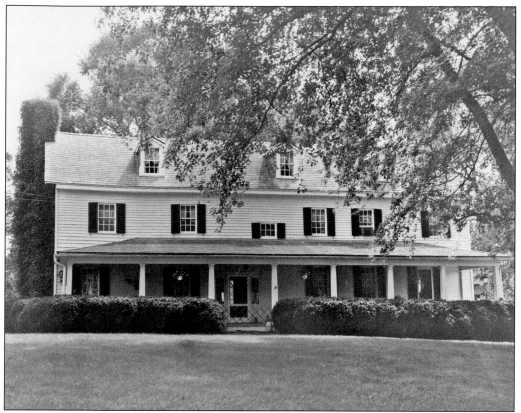

This 1974 photograph is of the R. H. Owings house of 1850. It is located at 9401 Lyons Mills Road in Owings Mills. Plinlimmon is an early-19th-century log home now covered in siding. Over time, the house has changed its facade to suit the occupants. Throughout its history, it has remained the quintessential farmhouse. (Courtesy of the Baltimore County Historical Society.)

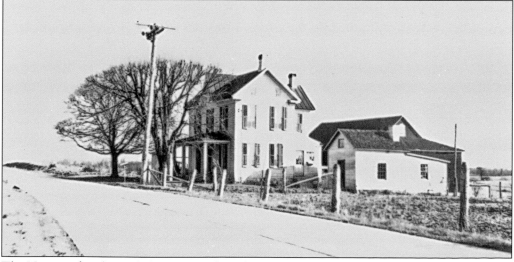

The Upperco farmhouse belonging to Elwood Culison sits at 3445 Black Rock Road. The home was built in 1876 and was owned by F. Markey in 1898, according to the 1898 Bromley Atlas. It is pictured here on December 8, 1939. (Photograph by Benjamin H. Engle.)

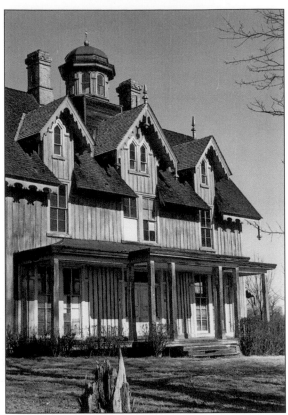

Ravenshurst, located at 4205 Antique Lane in Glen Arm, was built around 1856 for Moses Rankin and purchased in 1857 by Gen. Isaac Ridgeway Trimble. The Hoen family later owned it. Ravenshurst was a two-and-one-half story, Carpenter Gothic–style, board-and-batten home. Pictured here in the 1970s, Ravenshurst burned on October 31, 1985. (Photograph by John W. McGrain.)

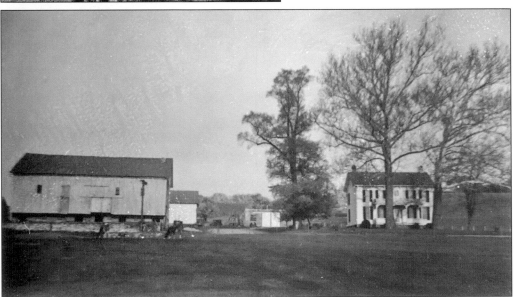

Huntley, the David Longnecker house located at 13706 Longnecker Road in Glyndon, was built around 1859 by the Given family. The house was described as a two-story frame house in a sale notice in the *Baltimore County Advocate*. The architecture of the home (here in 1941) was of the Greek Revival style, so popular at the time that it was also referred to as the national style. (Photograph by Louise Bland Goodwin.)

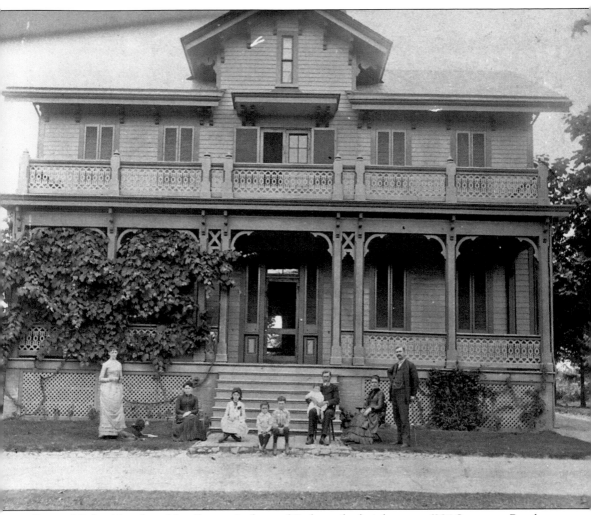

George Michael Lamb and family pose in front of Cedarcroft, their home at 6204 Sycamore Road. George Michael Lamb was the son of John Emerson Lamb, who, with his brother Eli, in 1847 started the Milton Academy at 14833 York Road in Sparks. George was educated there. Today the building that housed the Milton Academy is a fine restaurant, the Milton Inn. Cedarcroft is shown graced with intricate porch railings, corbels, and bracketed columns in this 1886 photograph.

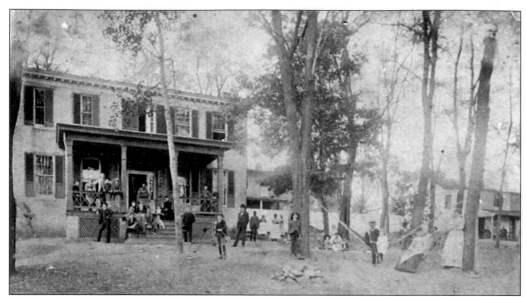

Zephaniah Poteet owned Mount Pleasant estate, located at 426 Sherwood Road in Cockeysville. He inherited the property and bought nine more parcels. His father, Thomas Poteet, purchased the first parcel of property in 1826 from Richard Pearce. The house is shown here with members and friends of the Poteet family gathered on the front lawn between 1887 and 1904. (Courtesy of the Historical Society of Baltimore County; photograph by Charles Quartley.)

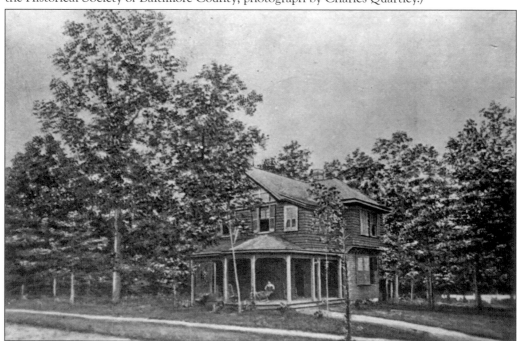

The 1900 screened image from the Sudbrook Company brochure shows a home at 1020 Windsor Road located in Sudbrook Park, Pikesville. Sudbrook Park was a subdivision built in 1889 on John Howard McHenry's 846-acre estate. Frederick Law Olmsted Sr., considered the founder of landscape architecture in America, designed the suburban community. It opened in springtime of 1890 with an entranceway bridge, train station, a hotel, and nine spec cottages.

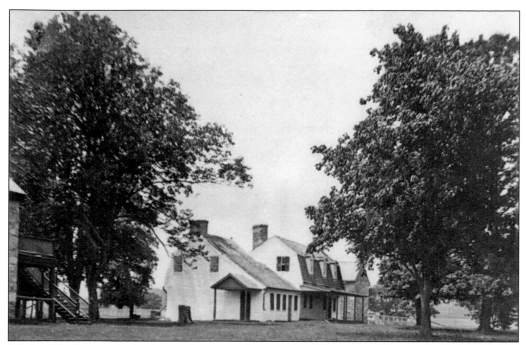

Michael Jenkins built this house, known as Jenkins Purchase, in Hydes in Long Green Valley. The house was built sometime between 1759 and 1767 but was later demolished after becoming infested with termites. The demolition is reported to have happened as early as 1899 or, according to the family, in 1906. This photograph dates to around 1895.

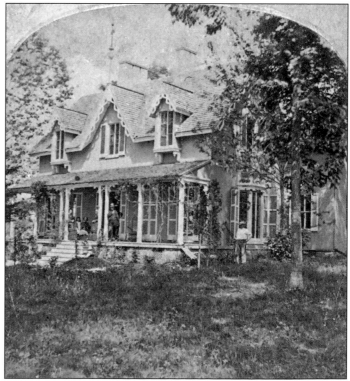

This 1872 stereo view of Oak Grove, the home of Dr. John Morris on Morris Avenue in Lutherville, shows three unidentified women and a child on the porch, left middle distance; an unidentified man to their right; and another on the side of the house. This early photograph shows the house prior to the addition of a servant's wing. (Photograph by W. M. Chase.)

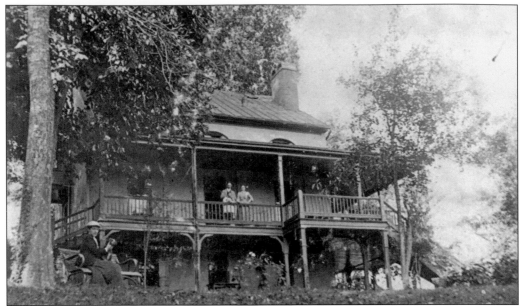

Guests and family members enjoy the c. 1892 views from the upstairs porch and grounds of Hillside Farm, situated on the banks of the Gunpowder River in Warren. This Baldwin family summer home was eventually sacrificed to make way for the Loch Raven Reservoir expansion project. (Photograph by William Woodward Baldwin.)

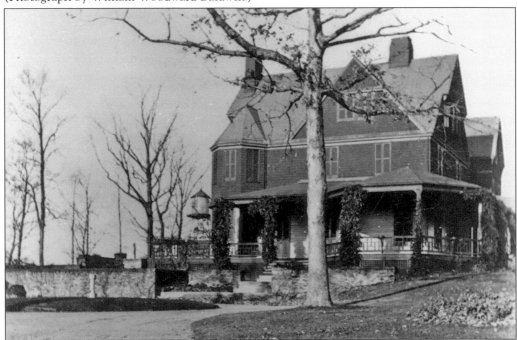

R. Brent Keyser's house (here on August 17, 1905) was located at the end of Cockeys Mill Road in Reisterstown. The property, known as the Mount and also referred to as Brentwood, was built on land purchased by his father, William Keyser. William purchased the tract of land in 1885 for his wife, Mary, from Col. William Norris, previously chief of the Confederacy Signal Corps. Fire destroyed the building during the 1940s. (Photograph by Joshua Fitze.)

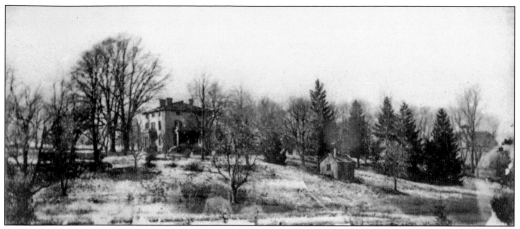

Auburn House was built around 1790 for Rebecca, widow of Capt. Charles Ridgley. Captain Ridgley was the builder of the Hampton Estate in Dulaney Valley. Hampton was left to Ridgley's nephew, Charles Carnan Ridgley, who was accused by the widow of treating her with the "greatest disrespect and slights." Rebecca received Auburn plus 244.5 acres by relinquishing any rights to her husband's estate. This c. 1900 photograph shows the replacement of the original 1790 Auburn House destroyed by fire on a stormy night in 1849. The Greek Revival building was subsequently used by Towson University.

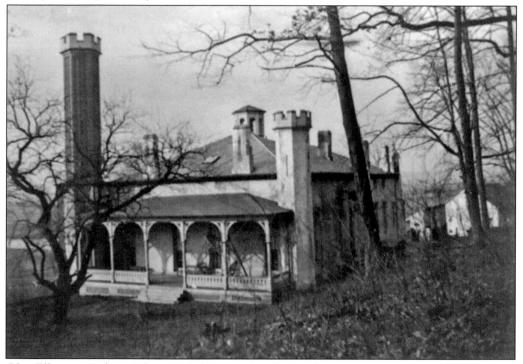

Glen Ellen was Robert Gilmor's Gothic mansion designed by Alexander Jackson Davis. Gilmor modeled his mansion after Sir Walter Scott's Abbotsford estate at Galashiels, south of Edinburgh. Gilmor, at the young age of about 20, admired the mansion while visiting. Glen Ellen had 18 rooms and one bathroom. Like so many others, Glen Ellen (here in 1917) was purchased by Baltimore City as part of the Loch Raven Reservoir expansion project. (Photograph by Lawrence Cowles Stoudenmir.)

The John Matthias (J. M.) Prigel house at 4851 Long Green Road was built around 1857 for Samuel Rankin and pictured in the 1930s. John and his wife, Wilhelmina, were active in the Church of the Brethren. John Matthias Prigel, also known as Brother Mott, was a minister for 49 years. His home was often used for Sunday services, and baptisms were performed in the stream on his farm. (Photograph by William C. Kenney.)

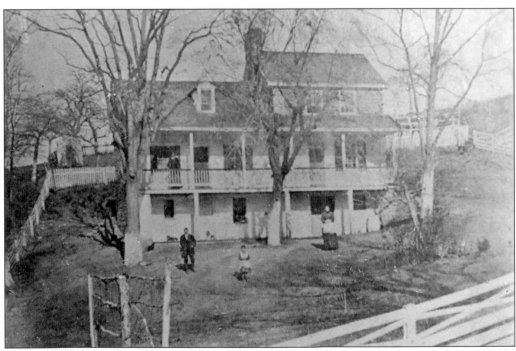

The c. 1898 exterior view of the Wesley Royston Cuddy (1828–1905) farmhouse in Stablersville shows a fall or early spring setting. Wesley was the son of Rebecca and Capt. Lawson Cuddy. He married Rachel Ann Stabler in June 1850. (Photograph possibly by Hester Ella Stabler.)

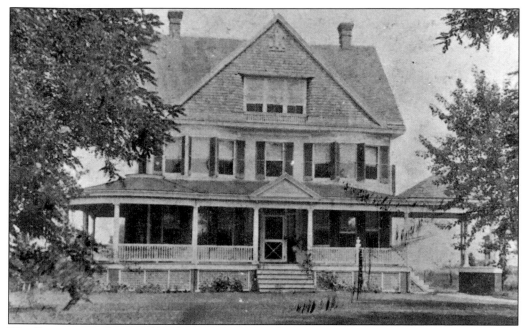

The Reisterstown house of banker Frank H. Zouck is shown on this postcard dated November 5, 1906. Robert Caron built the house, located at 337 Main Street, in 1901. Frank H. Zouck (1865–1950) was president of Reisterstown Savings Bank. He ran for Congress in 1922, promoting himself as "dry" on the anti-beer and wine ticket.

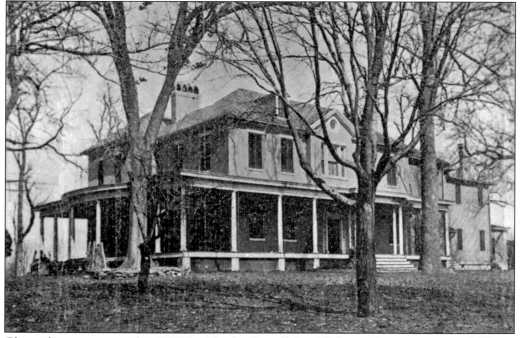

Clynmalira was surveyed in 1705 for Charles Carroll, Lord Baltimore's attorney general. Henry Hill Carroll, great-great-grandson of Charles Carroll, built Clynmalira at 15315 Carroll Road in Monkton in 1822. This c. 1906 photograph shows the Federal-style two-story manor home. Clynmalira was named after Carroll's home in Ireland.

William H. Ruby, born in 1830, reportedly laid the foundations of his home on March 20, 1869. His daughter, married to John Odell, later inherited the house. Later on it became the home of John Odell and his second wife, Mary Osborne Odell. The house was replaced by a Shell gas station and eventually became the site of the Towson Library. Mary Odell was the first Towson librarian around 1939. The photograph depicts a scene from about 1904.

The John W. Shanklin house at 8906 Satyr Hill Road was once known as Forest Hall. The house with dormers and closable shutters was demolished in the mid-1980s, and the property was subsequently subdivided. The photograph was taken in the 1940s or 1950s.

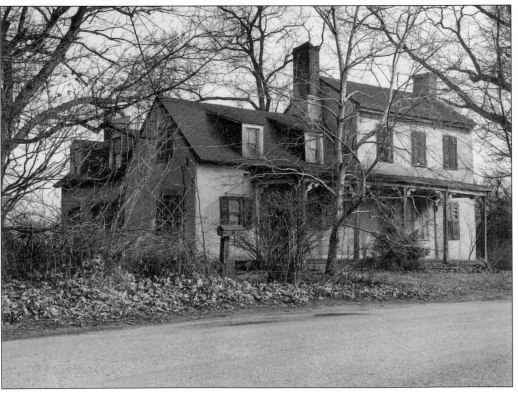

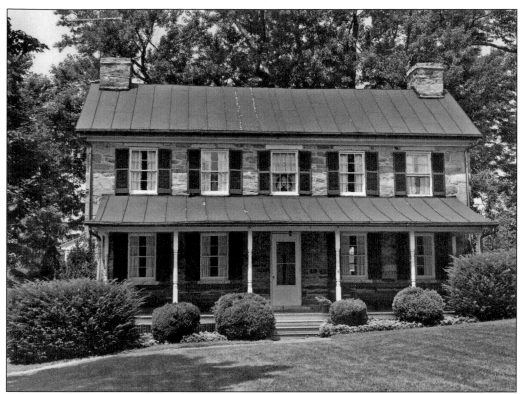

Belfast Retreat is located on the north side of Belfast Road between Wheeler Lane and Priceville Road in Sparks. The stone home represents an authentic farm homestead that was built by William Brooks on land his father, Charles Brooks the Elder, patented as "Belfast." The Brooks family built other homes in the area and provided the lot on which the Belfast public school was built. Belfast Retreat is flanked by chimneys on both ends and is dressed with a full-width front porch.

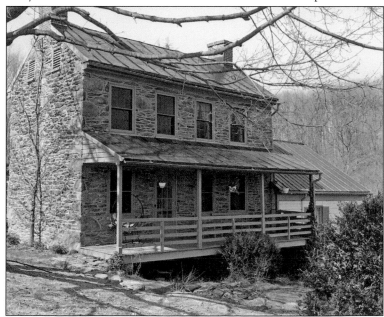

Capt. Robert Bockius owned Rippling Run Farm at 5126 Trenton Mill Road in Upperco during the time of this picture in 1976. Rippling Run is a stone dwelling with a date stone reading either 1846 or 1847. John Armacost was believed to be the original owner. He died in 1850, leaving the home and 111 acres to John W. Armacost. Rippling Run stands on an original land survey known as Elijah's Lot.

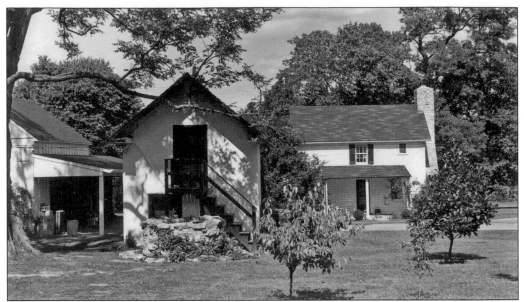

Green Spring, also known as the Ellen N. Moale house, is located at 112 Valley Road in Green Spring Valley. This historic home, built before the Revolutionary War, around 1762–1780, is one of the oldest homes constructed in Baltimore County. It is identified in the 1798 Federal District tax records and has remained in the same family since the 18th century. Green Spring is situated on the Green Spring Forest tract, a 1754 resurvey of several contiguous tracts originally laid out for Richard Gist in the early 1700s. (Courtesy of the Historical Society of Baltimore County.)

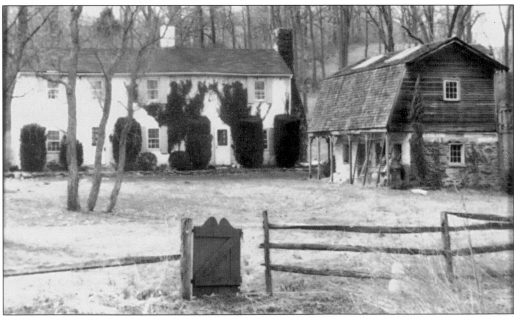

The c. 1762 Cotter house is located at 2702 Cotter Road in Millers. The historic log home is possibly the John Morrow house noted on the 1850 map. The 1877 atlas shows a residence of N. Cotter. Nicholas Cotter listed himself as being a farmer from County Kerry, Ireland, having settled in America in 1873. A springhouse with a front mansard roof is shown to the right of the Cotter home in 1992. (Photograph by William A. Andersen, M.D.)

Peter Mowell, Baltimore iron manufacturer, built his home and farm buildings between 1851 and 1856. Shown here is the stable on his Glencoe estate. Mowell was a very successful businessman and the father of 10 children. He was also a director in the Baltimore and Ohio Railroad, the Northern Central Railroad, the Chesapeake Bank, and the Peabody Fire Insurance Company. He died at Glencoe at the age of 64. (Courtesy of the Historical Society of Baltimore County.)

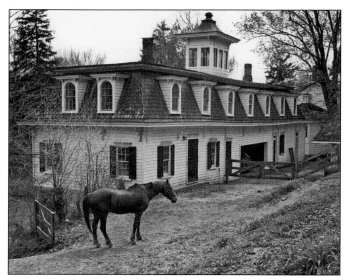

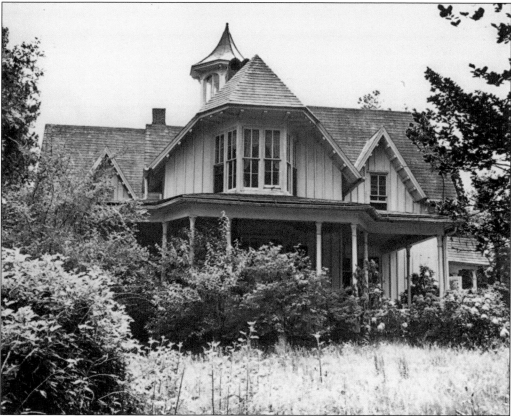

Dr. Horatio Gates Jameson built the Bare Hills house at 6222 Falls Road in 1857. Its Gothic Revival architectural style features steep gables and board-and-batten siding. A P. Babb iron pontiled soda bottle found in the stair construction by a worker during renovations helped date the home. Other artifacts and old letters dating from John Wright of the Rockland Bleach Works' occupancy of the 1880s were found in the property, pictured here in April 1976. (Photograph by G. W. Fielding.)

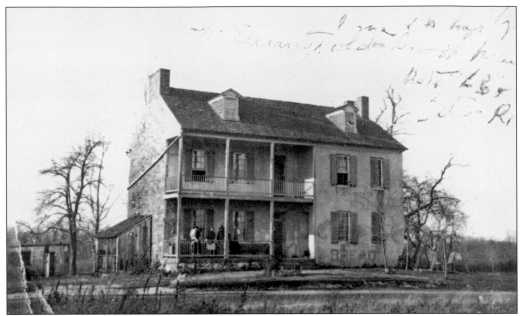

This photograph of Bishop's Tavern dates back to World War I. The house sat on Belair Road in Perry Hall. The two-story stone structure was built by 1844 on land acquired between 1812 and 1823. Also known as Bishop's Inn, the structure was significantly altered from the time of this photograph until the 1980s, when it was replaced by a fast-food establishment.

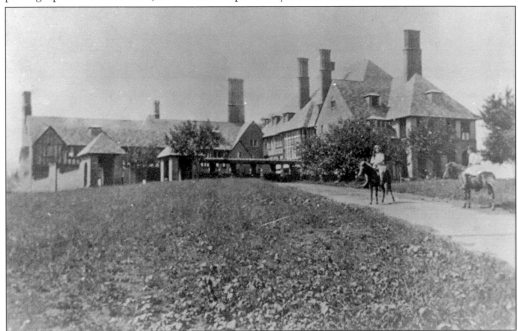

Pleasant Hill, the C. Wilbur Miller house on Falls Road, was built between 1911 and 1916. Shown here in the early 1920s, it was demolished in the early 1970s. The Miller family purchased Shawan Farm and remodeled and enlarged Shawan House, using it as the farm manager's house until 1932, at which time Pleasant Hill was sold and the family moved into Shawan House. Two young girls are on ponies at the carriage drive. (Photograph by the Baltimore Gas and Electric Company.)

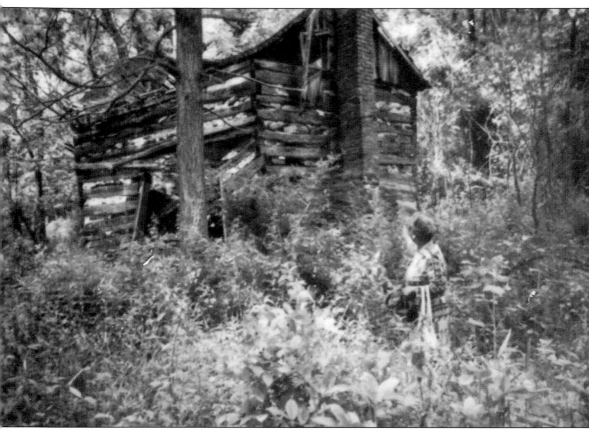

In the 1980s, Virginia Diggs White looks at the dilapidated remains of the former home of her grandparents John Eli Diggs and Nora Rachel Derrick Diggs, located near Fry Road in Boring. The historic secluded property lies adjacent to the author's farm. (Photograph by Louis Diggs.)

BIBLIOGRAPHY

Brooks, Neal A., and Richard Parsons. *Baltimore County Panorama.* Baltimore, MD: Baltimore County Public Library, 1988.

———. *A History of Baltimore County.* Towson, MD: Friends of the Towson Library, Inc., 1979.

Brugger, Robert J. *Maryland: A Middle Temperament 1634–1980.* Baltimore, MD: The Johns Hopkins University Press, 1988.

Bunting, Elaine, and Patricia D'Amario. *Counties of Northern Maryland.* Centreville, MD: Tidewater Publishers, 2000.

Doak, Robin. *Voices from Colonial America (Maryland 1634–1776).* Washington, D.C.: National Geographic Society, 2007.

Finlayson, Ann. *Colonial Histories Maryland.* Nashville, TN: Thomas Nelson Inc., 1974.

ABOUT THE ORGANIZATION

The Baltimore County Public Library (BCPL) photograph collection preserves more than 20,000 images of Baltimore County, Maryland, the Independent City of Baltimore, and associated locations. Librarian and community leader Richard Parsons established the collection in the late 20th century, accepting donations, borrowing family and institutional albums, and arranging for copies of material in local repositories. The initial collection was assembled in the Publications Department of the BCPL administrative offices. Sources of note include Edmund Kenney, George Blakeslee, Marvin Thomas Jr., Paul Dorsey, John McGrain, James Lightner, the Historical Society of Baltimore County, Patuxent Publishing, and the BCPL history rooms in the Catonsville, Reisterstown, and Towson branches. In 1988, BCPL published *Baltimore County Panorama*, a pictorial essay presenting the best selections from the collection.

The digitization effort known as the Baltimore County Legacy Web originated in 1995 as an unfulfilled Maryland Department of Education grant candidate. In the absence of funding, in 1996, BCPL technology specialist Jason Domasky and library volunteer Dr. James Hitzrot started scanning and organizing the thousands of photographs in the Publication Department archives. In the ensuing years, additional volunteers joined the project, and Parsons composed the metadata of several thousand images, fueled by the research support of county historian John McGrain and others. The project received support from the Maryland Department of Education and the Friends of the Towson Library in the form of temporary staff funding for a database specialist, new computer equipment, and furniture.

In 1999, the BCPL Web site introduced the Legacy Web, an online database of digitized photographs accompanied by descriptions. In the decade that followed, Domasky and Parsons maintained and expanded the volunteer-staffed project in the BCPL Towson branch mezzanine offices. Now nearly 20,000 indexed images constitute the database, and additional photographs, slides, and negatives are donated and digitized on an ongoing basis. Over the years, the collection has been highlighted at several community and public events. BCPL is proud to partner with Gayle Blum as a major contributor to Images of America: *Baltimore County*.

DISCOVER THOUSANDS OF LOCAL HISTORY BOOKS FEATURING MILLIONS OF VINTAGE IMAGES

Arcadia Publishing, the leading local history publisher in the United States, is committed to making history accessible and meaningful through publishing books that celebrate and preserve the heritage of America's people and places.

Find more books like this at
www.arcadiapublishing.com

Search for your hometown history, your old stomping grounds, and even your favorite sports team.

Consistent with our mission to preserve history on a local level, this book was printed in South Carolina on American-made paper and manufactured entirely in the United States. Products carrying the accredited Forest Stewardship Council (FSC) label are printed on 100 percent FSC-certified paper.

MADE IN THE USA